C000136254

THE
Archive Photographs
SERIES

RHONDDA

A SECOND SELECTION

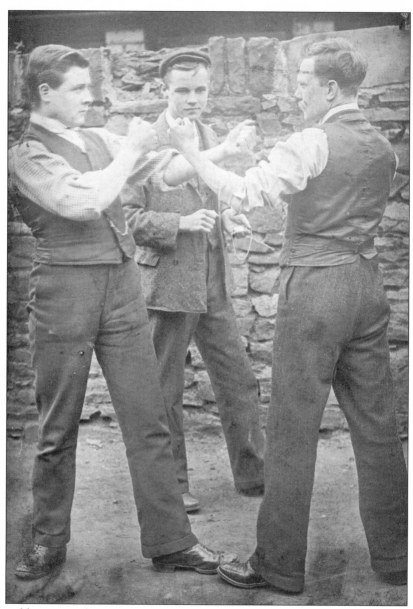

Two Rhondda men strike a menacing pose while their timekeeper looks on, *c.* 1900. Bare knuckle contests, on the hillsides or in fairground booths had provided much needed entertainment in the 'frontier communities' created by the South Wales coal rush. A fighting tradition was established that produced some of the greats of British and world boxing in the early years of this century: from Penygraig, Tom Thomas, British middleweight champion; from Porth, flyweight Percy Jones and featherweight Llew Edwards and of course the legendary Jimmy Wilde of Tylorstown (flyweight champion of the world 1916-1923), 'the Ghost with a Hammer in His Hand'. Though he weighed in at no more than 7st 4lb, Wilde was arguably the greatest pound for pound fighter that the world has ever seen; his superb natural timing and generation of staggering power meant that even as a youth he had been able to knock down opponents several stones heavier. In 1959 immortality was rightly bestowed on him when he was inducted into Boxing's Hall of Fame (see also page 81).

THE
Archive Photographs
SERIES

RHONDDA

A SECOND SELECTION

Compiled by
Simon Eckley and Emrys Jenkins
in association with
Rhondda Borough Libraries

CHALFORD

First published 1995
Copyright © Simon Eckley and Emrys Jenkins, 1995

The Chalford Publishing Company
St Mary's Mill, Chalford,
Stroud, Gloucestershire, GL6 8NX

ISBN 0 7524 0308 7

Typesetting and origination by
The Chalford Publishing Company
Printed in Great Britain by
Redwood Books, Trowbridge

This book is dedicated to Rachael Walsh.

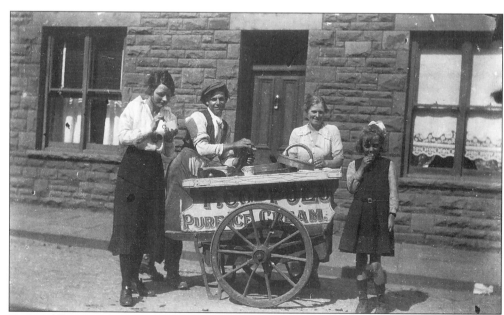

Fred Middleton pushing his ice cream cart, Gelli, 1920s.

Contents

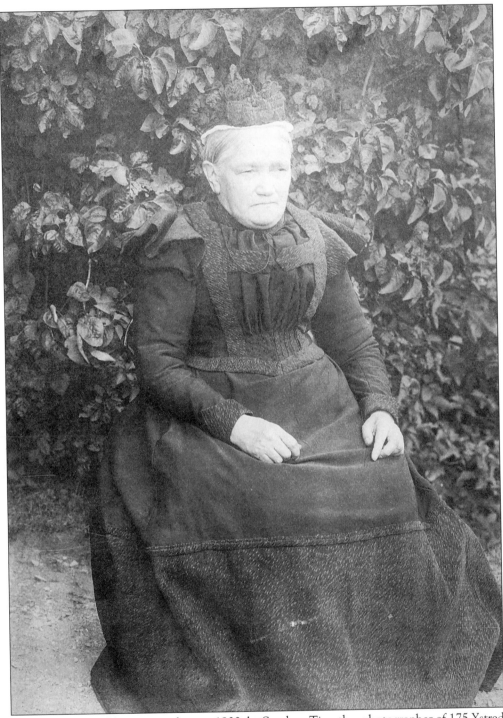

Portrait of a Rhondda woman taken, c. 1900, by Stephen Timothy, photographer of 175 Ystrad Road, Pentre. Without Timothy's excellent work in capturing on camera the people and working conditions in the Rhondda (see pp. 10-11), the pictorial history of the area would be much the poorer.

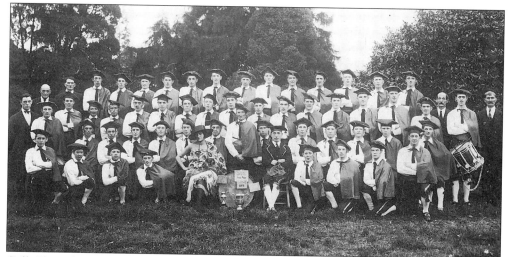

Gelli Toreadors, one of the most popular bands that raised morale during the 1926 Miners' Strike.

Introduction

by Dewi Griffiths, born Wyndham Street, Ton Pentre, August 1931

I still have them, over a thousand of them, in a cardboard box up in the attic of my present house in Tongwynlais. They're negatives of photographs I took myself from the age of twelve when I lived in the Maindy and Eastern Workmen's Hall and Institute, Ton Pentre, and I remember with a certain amount of pride that I also developed and printed the films and photographs myself. My mother wasn't too pleased as I spent hours using our bathroom as a darkroom; it wasn't so much the time as the chemicals which left multi-cloured stains on the enamel of the bath. Then again, she somehow smiled with approval as she realised that I was, in a way, recording the history of my little bit of the valley during those precious and happy years I lived there. Somewhere in that tightly packed box of negatives is perhaps the 'DNA trigger' that could bring back the busy shops on Pentre Hill, The Grand Cinema, The Bridgend Hotel, Ocean coal trucks on their way down the incline from the Maindy Colliery, The Coliseum in Gelli, St David's Church in all its glory, and of course that fount of knowledge and fun — Pentre Grammar School.

When the school had a reunion of boys and girls who were there almost fifty years ago, over a hundred of us turned up with scrapbooks full of special memories in the form of photographs: Form 6, the hockey team, the rugby team on an away fixture, and of course, that yard-long photograph of the whole school. these photographs produced an emotional reaction in all of us, mirrors of our youth, moments frozen in time, holding for ever our young, eager, hopeful faces as we anticipated life ahead.

Is there a house without such photographs? I doubt it! How else do we show our children what life and conditions were like when we were their age? And don't we find ourselves fascinated when we come across fading sepia photographs of our grandparents' time? Not only pictures of the family, but the streets, community institutions, chapel activities, shop fronts festooned with goods, miners' rallies, sports meetings, and always in the background those brooding waste tips. Without these histroic pictures it would be as if the era of 'King Coal' had never existed.

When Richard Llewellyn wrote *How Green was my Valley*, he had that rare gift of using words to bring us pictures of joy and sadness and the harsh reality of family life. Other great writers, like Glyn Thomas, have also conjured up memorable pictures of Band of Hope Sunday night concerts and chapel outings to the seaside; all, sadly, just memories now. But somewhere in our homes, and in left-over archives of original portrait saloons, are photographs that help us focus sharply on life in the valley since the late nineteenth century. How else would we know what an old Rhondda tram looked like, or the hilarious activities of a miners' jazz band, or that there were once horse shows in Ferndale, carnivals in Porth and hundreds of level mines along the sides of our mountains?

There is no doubt about the value of, not just finding and preserving these old images, but publishing them in a book such as this. I ignore people who suggest that it is no use living in the past. They're missing the point! What these photographs do is to provide a key that unlocks the door to warm memories and stimulates fierce pride in the courage and achievements of valley folk. They remind us of the incredible inventiveness and perseverance of our forebears who found happiness in the most awful of circumstances. Their common adversity, the all-too-often disasters, and the poverty of the depression years forged a strength and passion that made the spirit of the Rhondda comparable to that of London's East End and the Bronx in New York.

I know from present-day experience that memories of those good old, bad old days are precious. Many thousands of people listen to my weekly radio programme, *A String of Pearls*, and a constant flow of letters tells me that a song or a singer reminds the sender of their youthful romantic days, and of times when all the family were together, before the young ones went out to take their chances in the big wide world.

And this collection of historic photographs has a similar effect. It reminds us of where we come from, who made us, what we are, and that nothing remains the same. Progress is all very well, but it tends to push everything aside, bull-dozing history in the name of development.

I am sure that everyone who studies this wonderful collection will be, as I am, profoundly grateful to everyone concerned for providing us with a welcome opportunity to have an encapsulated history of the Rhondda we love at our fingertips, on a bookshelf at home. And I wonder, will you, as I did when showing a photograph in a similar book to my children, point at a handsome young man and say, 'that's my dad — the grandfather you never knew.' You may not find a relative or a picture of the house in which you were born, but what you will find is a graphic reminder of your roots, a heritage of which you will feel rightly proud.

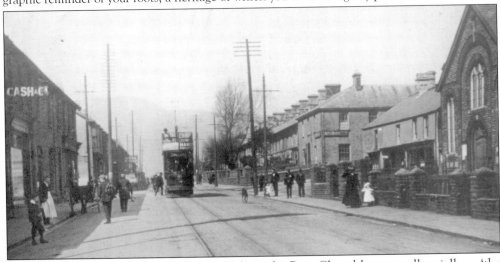

Bute Street, Treherbert, c. 1910. On the right is the Bute Chapel known colloquially as 'the Sticky chapel' after the minister's call on the congregation to 'please be upstanding' was once met with disaster owing to the undried varnish which had recently been applied to the seats!

One
One Community

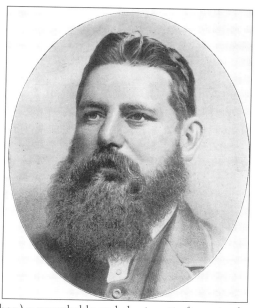

William Abraham (Mabon) a remarkable and charismatic figure in the emerging South Wales labour movement during the last decades of the nineteenth century and the first of this century. He was born in 1842 in Cwmafan and came to the Rhondda in 1877 as agent for the Cambrian Miners' Association. In keeping with his Liberal instincts regarding the unity of interest between master and man, Mabon was instrumental in the establishment of a sliding scale payment system which operated from 1875 to 1903 and regulated wages in accordance with the selling price of coal. In 1888 he won his most famous victory, that of a holiday for the miners on the first Monday of each month - Mabon's Day. In 1885 he became Liberal M.P. for the new Rhondda constituency defeating Lewis Davis, a Rhondda Fach coal owner by 3,859 votes to 2,992. He was the first Welsh working class M.P. at Westminster and represented the Rhondda there until 1920. Mabon was also President of the South Wales Miners' Federation from 1898 until 1912 when his conciliatory views finally became unreconcilable with those of younger, more militant, lodge officials in the 'Fed'.

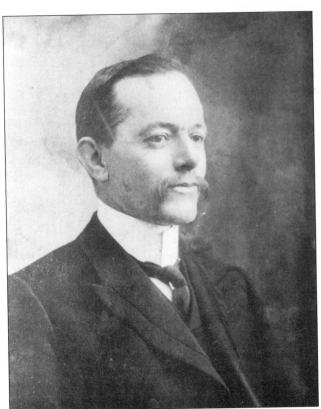

Mr Octavius Thomas, Engineer and Manager of the Rhondda Urban District Council's Gas and Water Department (1898-1934).

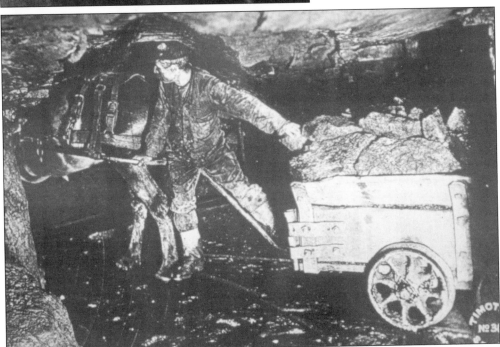

Haulier bringing coal out from the face, Rhondda mine, 1890s. This was part of a series of underground views published by Stephen Timothy.

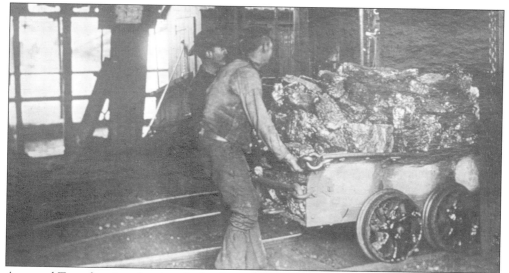
A second Timothy view showing the landing of coal at the pithead, probably 1890s.

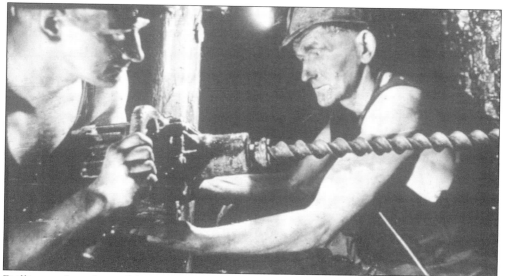
Drilling work at the coal face, Rhondda, 1930s.

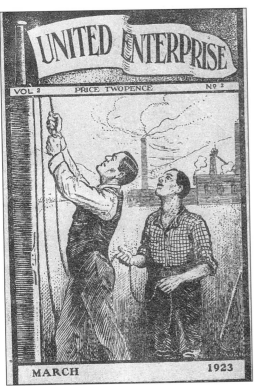

The March 1923 edition of the *United Enterprise*, a monthly digest of news, humour and practical hints. It was produced by the Western Mail Ltd in Cardiff for a readership primarily in the Rhondda valleys.

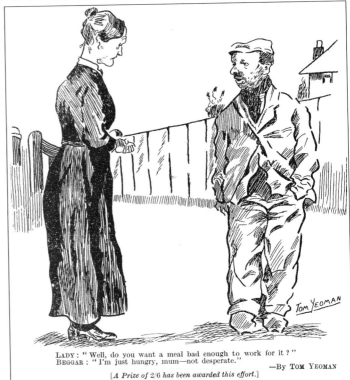

LADY : "Well, do you want a meal bad enough to work for it?"
BEGGAR : "I'm just hungry, mum—not desperate."
—By TOM YEOMAN

[*A Prize of 2/6 has been awarded this effort.*]

A cartoon by Tom Yeoman of Treherbert published in the above March 1923 edition of the *United Enterprise*.

WILLIS CINEMAS LTD. Present

PICTUREDROME, Tonypandy

WEEK COMMENCING MONDAY, JANUARY 20

Mon., Tues., Wed.:
CARROLL BAKER
PETER VAN EYCK

STATION SIX SAHARA

Showing: 5.10, 8.30 p.m. Also

ROBERT TAYLOR, VERA MILES

RECOIL

Showing ONCE Only: 6.50 p.m.

NEWS: 5 p.m. 8.20 p.m.

Thurs., Fri., Sat.:
HENRY FONDA
MAUREEN O'HARA

SPENCER'S MOUNTAIN

(Technicolor)
Showing: 5.45, 8.40 p.m. Also
MAXINE AUDLEY
RICHARD LEECH

RICOCHET

Showing: 4.40, 7.40 p.m.
NEWS: 4.30, 7.30 p.m.
Continuous Saturday: 2 p.m.

GRAND, PENTRE

Mon., Tues., Wed.:
ELVIS PRESLEY in

IT HAPPENED AT THE WORLD'S FAIR

Showing: 5.00, 8.30 p.m. Also

Swordsman Of Siena

(CinemaScope, Colour)
Starring STEWART GRANGER
Showing: 6.45 p.m.

Thurs., Fri., Sat.:
HAYLEY MILLS in

SUMMER MAGIC

Showing: 5.00, 8.30 p.m. Also

Sammy, The Way-Out Seal

Showing: 6.50 p.m.

Matinee, Saturday, remember, at 2 p.m.

COMING SOON: "A GATHERING OF EAGLES." Rock Hudson.

ABERGORKY HALL, Treorchy

Mon., Tues., Wed.:
GREGORY PECK in his Academy Award Performance

TO KILL A MOCKING BIRD

Showing: 4.40, 8.15 p.m. Also
JAMES DRURY
CHARLES BICKFORD

The Devil's Children

(Colour) Showing 7 p.m. Only

Thurs., Fri., Sat.:
ELVIS PRESLEY, JOAN O'BRIEN

IT HAPPENED AT THE WORLD'S FAIR

(PanaVision, Metro Colour)
Showing: 5 p.m., 8.20 p.m. Also
STEWART GRANGER

Swordsman Of Siena

Showing 6.45 p.m. only

PLAZA CINEMA, Tonypandy

MON., TUES., THURS., FRI., SAT. FOR FIVE DAYS ONLY.
CHARLIE DRAKE

THE CRACKSMAN

Showing: 5.15, 8.25 p.m. ALSO
PHIL CAREY

BLACK GOLD

Showing: 4.30, 7.15 p.m.

WEDNESDAY NIGHT IS "BINGO" NIGHT

Advertisement placed by Willis Cinemas Ltd in the *Rhondda Leader*, 18 January 1964. The same edition of the *Leader* ran, as its main story, a nostalgic piece on the demolition of the Empire Theatre in Tonypandy to make way for a new Woolworth's. The age of the picture-houses was then drawing rapidly to a close as television assumed dominance of popular entertainment culture both in the Rhondda and the country as a whole.

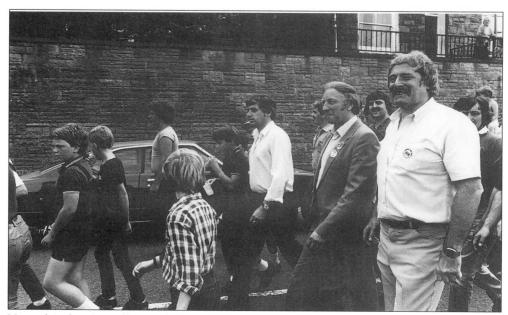

Visit of Arthur Scargill, President of the National Union of Mineworkers to Rhondda during the Miners' Strike, 16 June 1984. He is seen, above, accompanied by Des Dutfield who in 1984 had succeeded Emlyn Williams as President of the N.U.M. in South Wales. Leaving to one side the blame that can be placed when two megalomaniacs clash (Scargill v Thatcher) it seems clear that the 1984-85 Miners' Strike greatly speeded the untimely death of deep mining in South Wales (with the noble exception of Tower) and has left in the area further economic and social scars which should have been avoided. The exceptional solidarity shown in Wales during the struggle -only 6 per cent of miners broke the strike and not one at Mardy - was to be in vain.

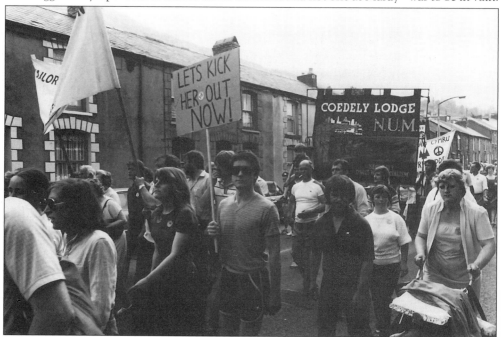

Two

Blaenrhondda, Blaencwm and Treherbert

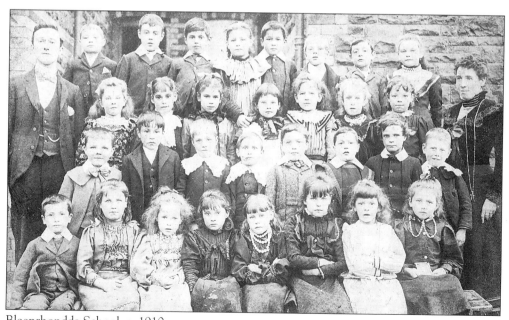

Blaenrhondda School, *c*. 1910.

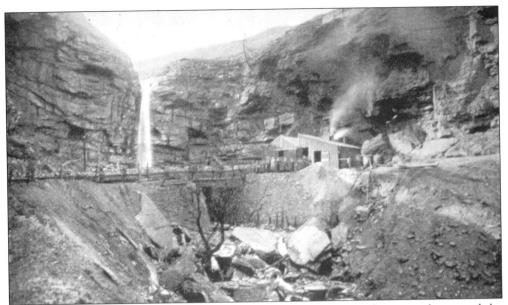

The waterfall at the top of the Rhondda Fawr valley, *c.* 1900. Note the engine house and the entrance to the Fernhill Company level. The buildings and the bridge across the stream are now gone although the rusted shell of the engine can still be seen.

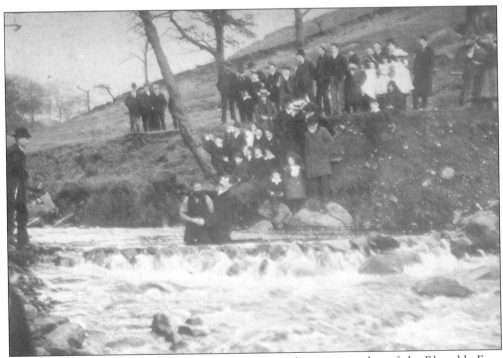

A baptism being performed in what is thought to be the upper reaches of the Rhondda Fawr river, *c.* 1900.

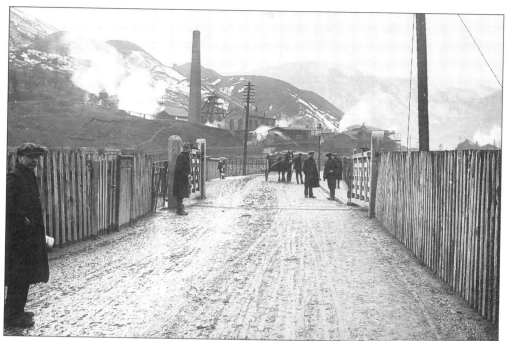

Old level crossing in Tydraw Terrace, Tynewydd, showing Tydraw Colliery (closed in 1959) in the background, c. 1910. The railway track from Fernhill Collieries crossed the road here before joining up with the line from the Blaencwm (Glenrhondda) and Tydraw collieries.

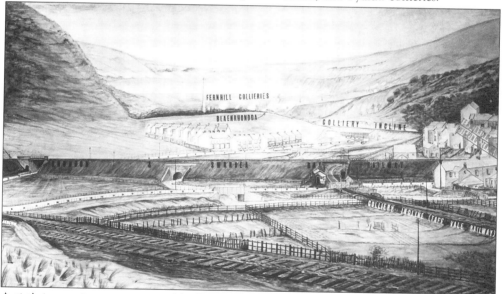

Artist's impression commissioned by E. Hazledine Barber, engineer and surveyor for Rhondda Urban District Council (1914-1920) showing the tangled network of railway lines at the top of the Rhondda Fawr valley, c. 1914. The dots which run along the road indicate the proposed extension (never built) of the tramway from Tynewydd to Blaenrhondda. The first tramcar had run into Treherbert on 12 September 1908 and in April 1912 this service had been extended to Tynewydd. Also shown, centre right, is the level crossing over the Taff Vale Railway shown in the picture at the top of this page.

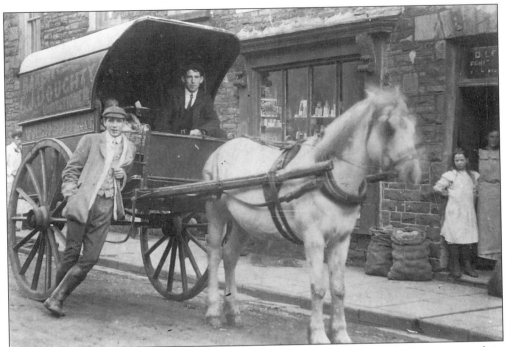

Delivery cart of Charles J. Doughty, baker and confectioner of Treherbert, pictured in Dunraven Street, Tynewydd, *c.* 1910. Mr Doughty is leaning against the cart which was pulled by Polly the pony.

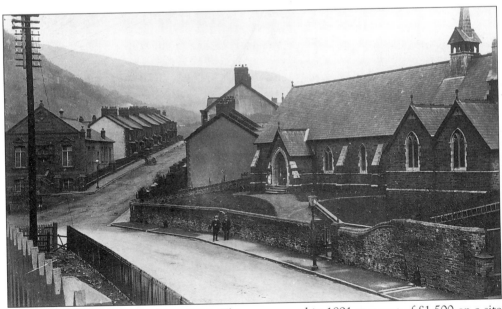

St Alban's Church, Tynewydd, *c.* 1914. This was opened in 1891 at a cost of £1,500 on a site donated by the Earl of Dunraven. Seating was provided for 350 people. On the left of picture is the Fernhill Institute, commonly known as 'The Palace'. It was destroyed by fire on 25 March 1985.

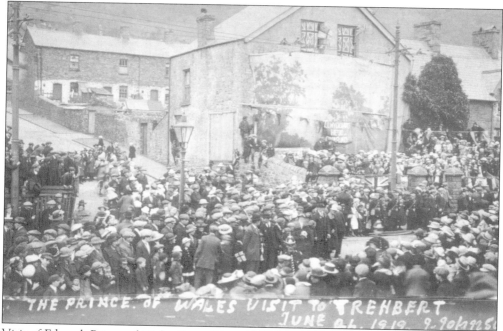

Visit of Edward, Prince of Wales (later Edward VIII), Stuart Square, Treherbert, 9 June 1919. The disguised building in the background was the Railway Institute. It was in such bad repair at the time of this royal visit that, presumably in order not to offend the prince's eyes, a canvas sheet was painted with trees and hung over the side facing the road! During the Second World War the building was used as the local headquarters of the Home Guard.

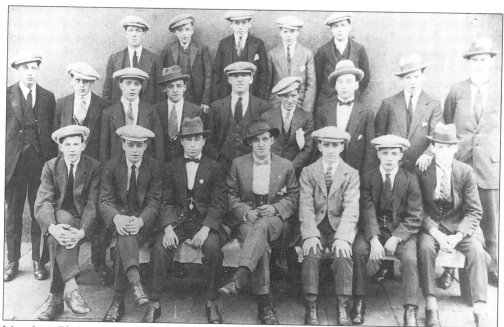

Men from Blaencwm pictured before a charabanc outing, possibly to the races, c. 1918. Among those pictured are George Berry (centre of front row) and Tom Bugler (centre of second row with the black tie).

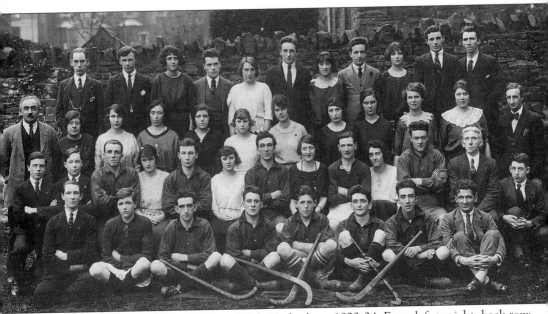

Emmanuel (Golliwog) Mixed Hockey Club, Treherbert, 1923-24. From left to right, back row: J. Oates, D. Thomas, C. Pickens, D.R. Davies (Vice-chair), E. Davies, J. Phillips, P. Williams, I. Rees, E. Jones, R. Thomas, G. Thomas. Third row: E.H. Powell (President), E. Thomas, C. Melville, M. Thomas, M. Houghton, M. Bell, E. Daye, G. Noble, M. Phillips, M. Thomas, L. True, H. Finlay. Second row: A. Blatchford, J. Hardwick (Treasurer), L. Thomas, N. Roberts (Secretary), G. Payne, L.M. Williams, D.J. Pickens (Captain), J. Biggs (Vice-Captain), B. Mundy (Chairman), A. Pickens, A. Phillips, L. Griffiths (umpire), G. Oates. Front row: H. Guy, A. Houghton, W. Pickens, W. Williams, H. Bryant, A. Pickens, G. Powell (Financial Secretary), L. Griffiths.

Bute Street, Treherbert, 1920s. 'Pencelli', then the house of Gorwel Owen, solicitor (and now the dentist's surgery of his grandson, Celfyn R. Owen) can be seen on the left, In the distance both Treherbert police station (demolished 1967) and Penyrenglyn School are clearly visible.

Mr Fennick Williams outside his ironmongery shop at 45 Wyndham Street, Tynewydd, *c.* 1910. The boy is John Anfield Jones who in later life became Senior Commissioner for the Out Islands of the Bahamas.

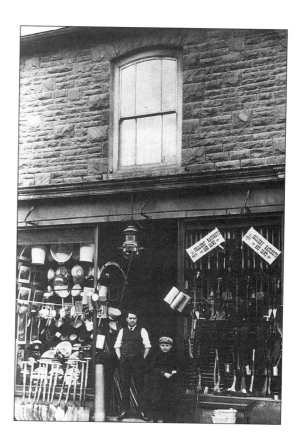

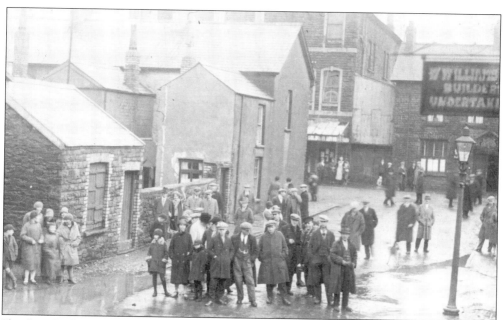

Floods in Taff Street, Treherbert, 1926. The man in the trilby hat next to the wall is Michael Davies, undertaker.

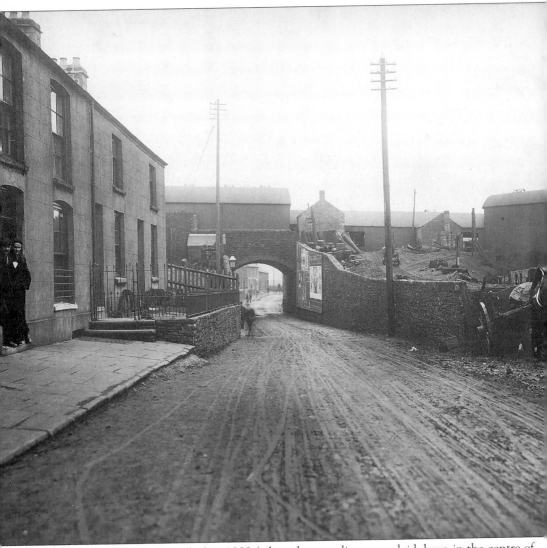

Old Ynysfeio railway bridge, before 1908 (when the tram lines were laid down in the centre of the road).

Ynysfeio bridge viewed here shortly after its reconstruction and the widening of the road in 1926-27. It was not removed until the early 1970s.

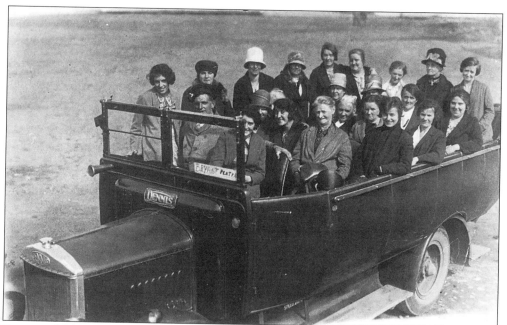

Emmanuel Chapel charabanc outing to Porthcawl, 1920s.

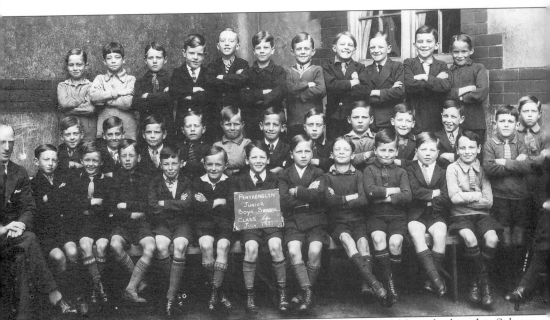

Class 4 at Penyrenglyn Junior Boys' School, July 1931. The boy holding the board is Selwyn Davies who later became an undertaker in Tynewydd..

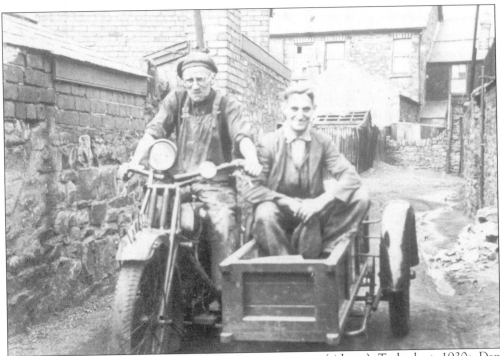

Dan Davies, builder (bike) and Handel Davies, ironmonger (sidecar), Treherbert, 1930s. Dan was the father of John Haydn Davies, the conductor of Treorchy Male Voice Choir.

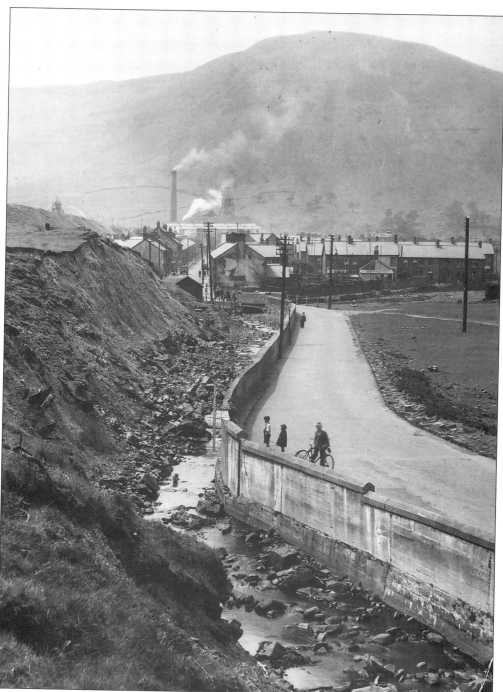

View of Blaencwm in 1937 showing the Glenrhondda Colliery headgear (No. 1, on the left, just over the brow of the slope; No. 2, towards the centre) rising up above the village. Glenrhondda No. 1 was opened in 1911 by the Glenavon Garw Colliery Company and in 1913 it employed 230 men. The 'New Pit'- No. 2 was opened after the First World War in 1921. Although never a huge concern by the standards of other Rhondda collieries, Glenrhondda was worked until 1966 when it was closed by the N.C.B.

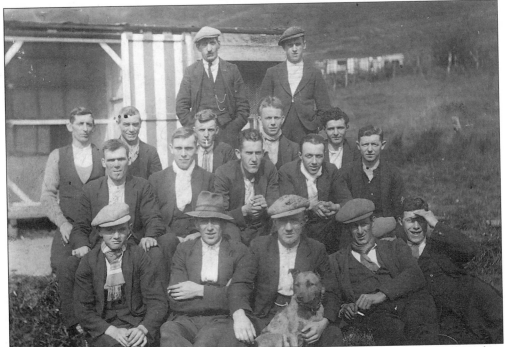

Group of men outside the pigeon cote and 'all purpose male hideaway' of Jack and Will Hughes, rear of Herbert Street, Penyrenglyn, c. 1937. From left to right, back row: -?-, Will Tasker. Third row: Will Hughes, -?-, Jack Jones, -?-, Dai Owen. Second row: Jim Wilkins, A. Greedy, Mogg Jones 'Bola', Dai Morgan, Ned Taylor. Front row: Thomas 'Butch', Will Thomas 'Trefleming', Glyn Jones, Rupe Jones, Tom Jones. The site is now covered by part of the Libanus housing estate.

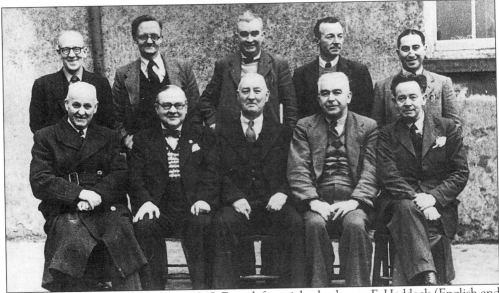

Staff of Treherbert Boys' School, c. 1945. From left to right, back row: F. Haddock (English and Welsh), Mr Oliver (History), C. Evans, -?-, D.F. Williams. Front row: -?-, 'Potty' Pearce, Mr Lewis (Headmaster), Mr Davies (Maths), Mr Duggan (Art).

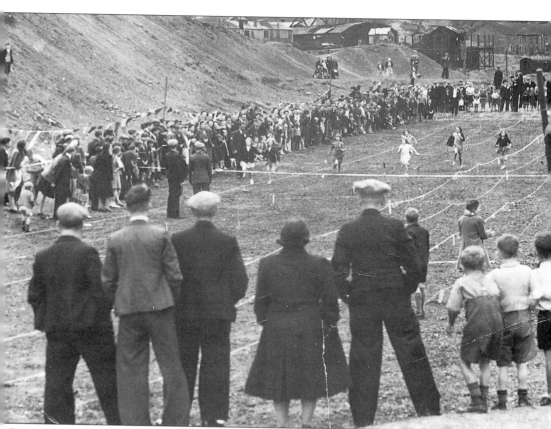

Penyrenglyn sports day, c. 1943. This was held on the Ynysfeio tip which, to enable racing to take place, had been hand-cleared and swept of coal debris and stones by local people.

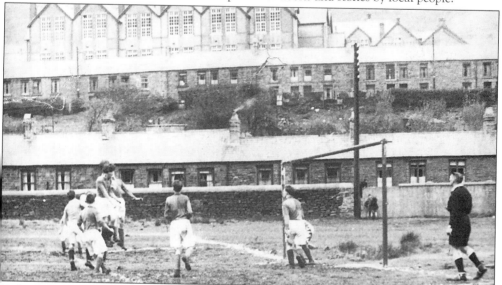

Treherbert Town football team playing a league match on Ynysfeio Field, c. 1947. The referee s Alby Nicholas from Pentre. Surviving players here and on other 'tip' fields still bear the scars ustained by tackling on the rough grassless surfaces.

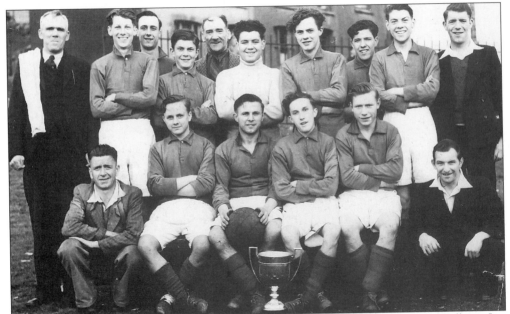

Treherbert Town junior football team, 1947. From left to right, back row: Jim Wilkins, Les Jones, Roy Morgan, Donald Fisher, Levi Emanuel (father of John Emanuel, current manager of Ton Pentre A.F.C.), Des Green, Gwyn Owen, Stan Eddy, Em Jenkins, John Cambell. Front row: Georgie Fisher, Derek Lewis, Norman Penhale, Gwyn Williams, Kenny Beach, Alby Oliver. The team is a picture of sadly short-lived triumph as the cup they were displaying was taken back a few days later because an illegal, i.e. overage player had represented them in the competition!

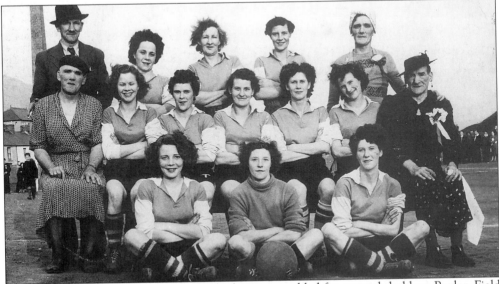

Treherbert Town ladies football team which was assembled for a match held on Baglan Field during the Festival of Britain celebrations in 1951. From left to right, back row: Trevor 'Scoop' Jones (the local newspaper reporter), Olive Griffiths, Eileen Emanuel, May Shephard, Gwilym Tanner. Middle row: Jim Wilkins, Eirwen Davies, Jean Beach, Liz Fisher, Olive Jones, Myra Smith, Levi Emanuel. Front row: Eileen Husband, Bronnie Smith, Jeannie Jones.

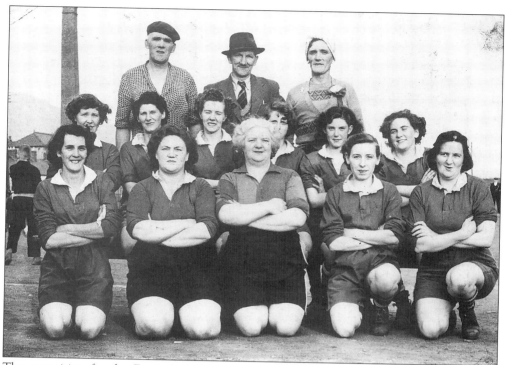

The opposition for the Festival of Britain match, 1951. From left to right, back row: Jim Wilkins, Trevor 'Scoop' Jones, Gwilym Tanner. Middle row: Gwen Wilkins, Betty Tanner, Lil Williams, Joan Owen, Gladys Tanner, Evelyn Dutfield. Front row: Dolly Richards, Myra Oliver, Mabel Green, Violet Morris, Beattie Glover.

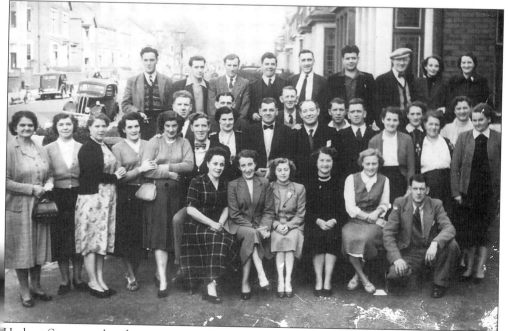

Herbert Street weekend outing pictured in Blackpool, c. 1956. The majority of the group was from this one street or the neighbouring Ynysfeio Avenue.

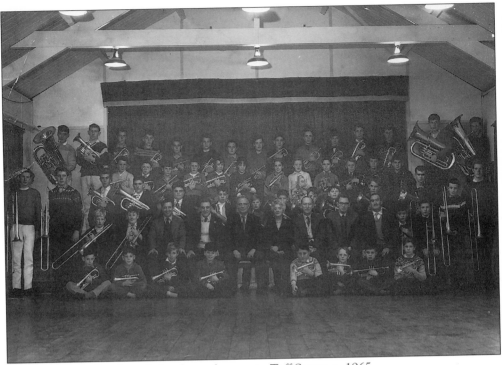

Treherbert Brass Band, at their rehearsal rooms in Taff Street, *c.* 1965.

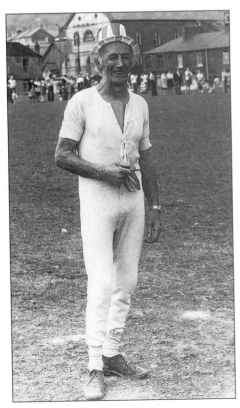

Tommy ('Tippit') Jenkins, a well known Treherbert character, seen here in his referee's outfit for the women's football match held during the Investiture celebrations of July 1969.

Three
Treorchy and Cwmparc

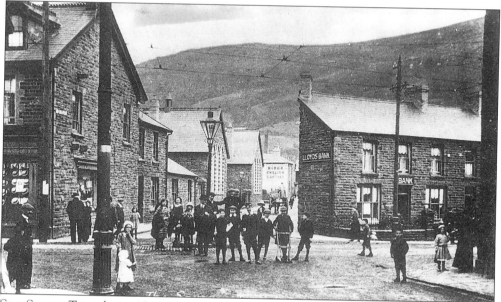

Stag Square, Treorchy, *c.* 1913. The front gardens of the terrace on the right were later cleared to improve access for the National Eisteddfod of Wales which was held at Treorci in 1928. No. 11 High Street, far left of picture with the selection of hats in the window, was occupied at this time by Lloyd & Co., drapers. Note the Horeb English Baptist Chapel (opened 1874) in the background, the site of which is now occupied by a doctor's surgery.

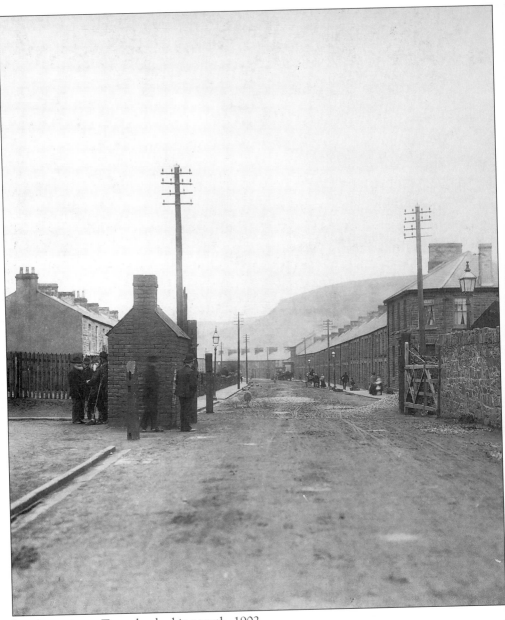

Level crossing at Treorchy, looking south, 1902.

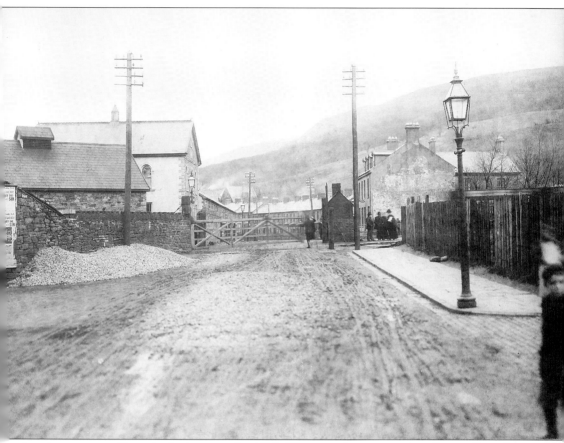

Level crossing at Treorchy looking north, 1902. The gates here stopped traffic to allow the passage of coal from Abergorki Colliery to a marshalling yard at Tylacoch.

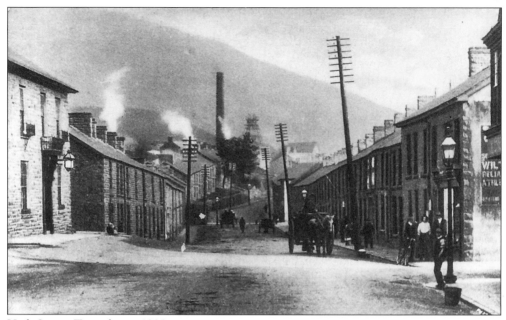

High Street, Treorchy, *c*. 1900.

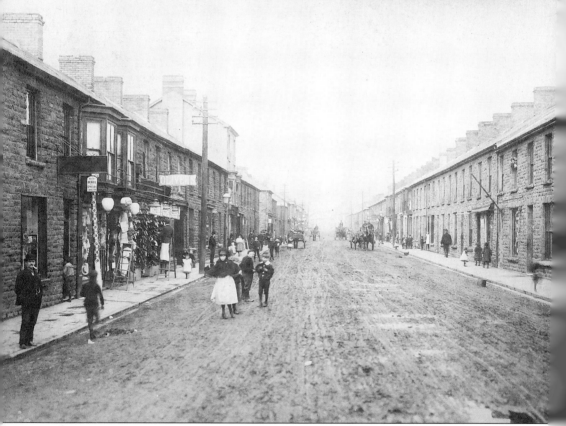

Bute Street, Treorchy, *c*. 1902.

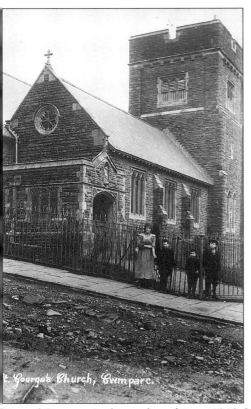
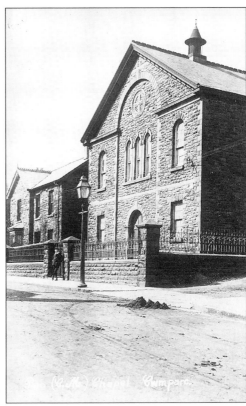

Two of Cwmparc's places of worship, *c.* 1910. Left: St George's Church which was consecrated on 22 December 1896. Right: the Parc Calvinistic Methodist Chapel.

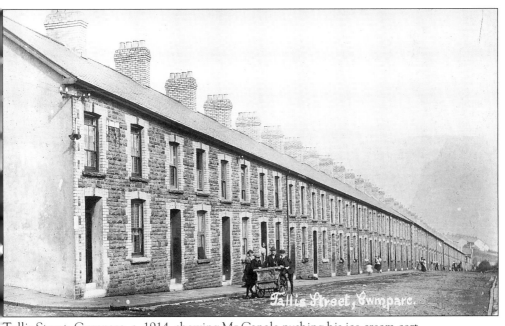

Tallis Street, Cwmparc, *c.* 1914, showing Mr Canale pushing his ice cream cart.

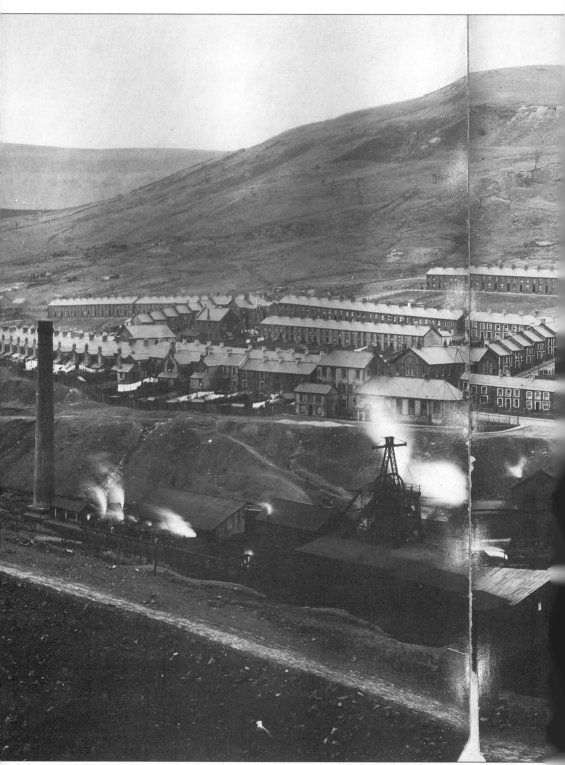

View of Cwmparc, *c.* 1920, showing the Dare Colliery (closed 1955) in full operation.

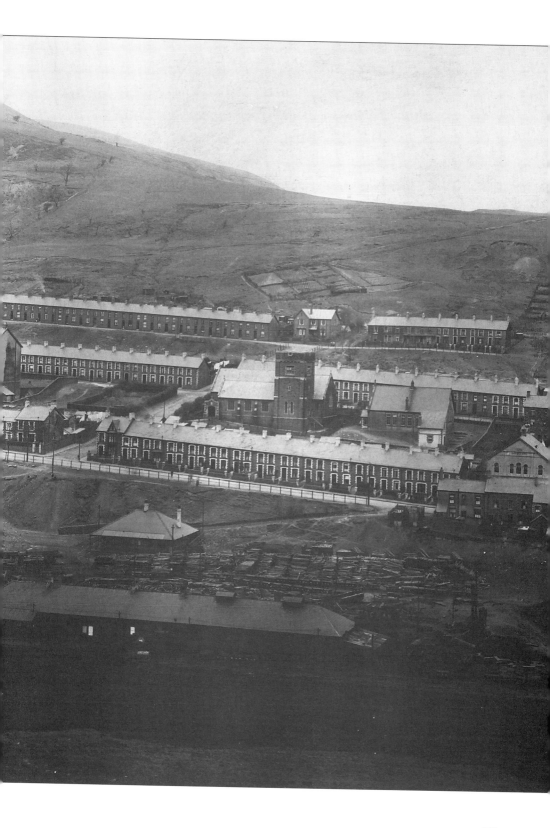

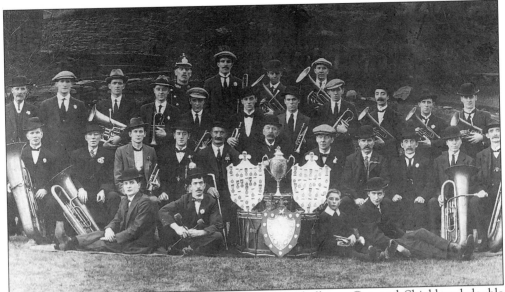

Abergorky Town Band, winners of the Association Challenge Cup and Shield and double medallists, 1918 season. From left to right, back row: Sergeant Mitchell, P. Lane, A.H. Davies, E. Hart. Third row: P. Hicky, D. Vaughan, R. Jones, G.P. Jones, S. Brooks, D. Fisher, W. Fisher, J. Hickerton, A. G. Shepherd (Secretary), T. Evans, J. Warren. Second row: T. Butler, T. Amos, B. Harries, E.J. Jones (Deputy conductor), J. Turner (Chairman), J.G. Dobbing (Conductor), A. Williams, Esq., M.E. (Vice-President), R. Fell, H. Turner, H. Paynter, J. Hickerton. Front row (on ground): A. Warren, J. Jones, S. Hart, J. Hickerton.

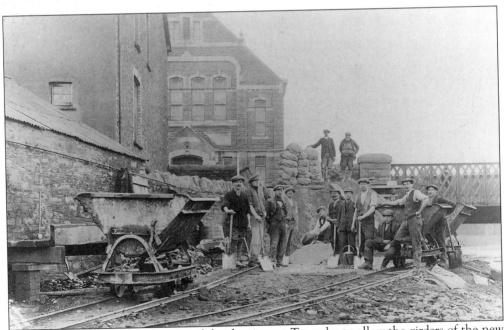

Workmen laying a narrow gauge track by the river at Treorchy to allow the girders of the new bridge to be moved into position, c. 1920. The Station Road English Calvinistic Chapel (opened in 1901) can be seen in the background.

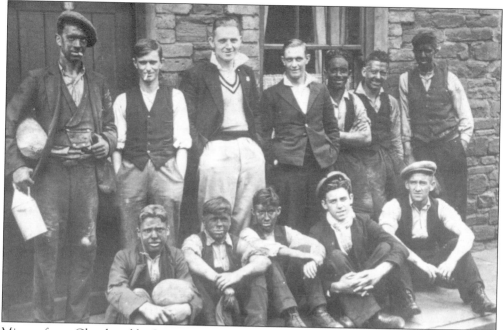

Miners from Glynrhondda Street, Treorchy, 1930s. Pictured second from the left with a cigarette in his mouth and hands in pockets is Will Moon.

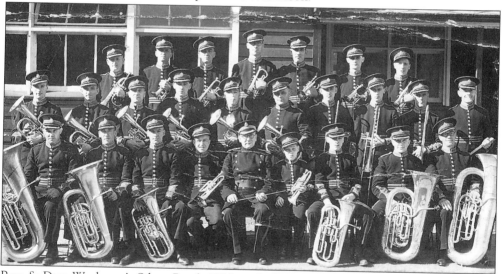

Parc & Dare Workmen's Silver Band, 1939, with their full-time conductor, Mr Haydn Bebb pictured centre with his baton in hand. Under his influence the band's repertoire and quality increased significantly; in this year - 1939 - they won various contests and took second prize in their class (A) at the National Eisteddfod of Wales held at Denbigh. The band began its life as the Cwmparc Drum and Fife Temperance Band in 1893 with fines imposed on any members caught drinking. Connections with the temperance movement were soon dropped, however, and the following year they became the 'all brass' Cwmparc Silver Band. In the 1970s, under the baton of Ieuan Morgan, the Parc and Dare became the only band in Wales ever to achieve a hat-trick of wins at the National Eisteddfod (1976-78). In 1993, its status among the best in Wales secure, the band was able to enjoy well-deserved centenary celebrations.

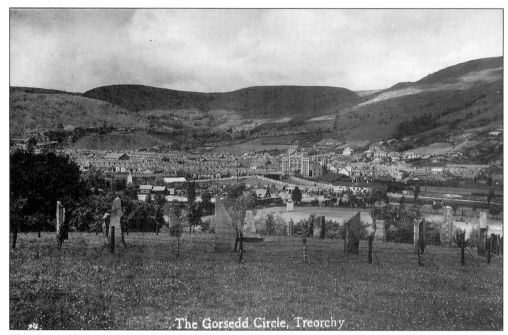

The Gorsedd circle, *c*. 1947. This was erected by Mr William Taylor, a stonemason from Ton Pentre, for the 1928 National Eisteddfod of Wales held at Treorci.

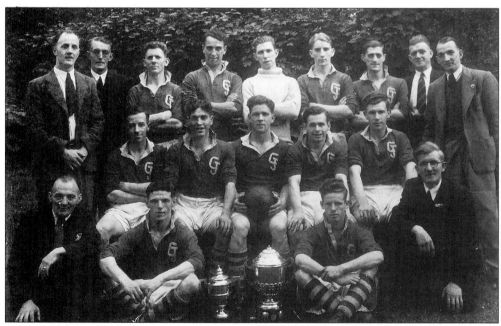

Cwmparc Juniors football team, *c*. 1948.

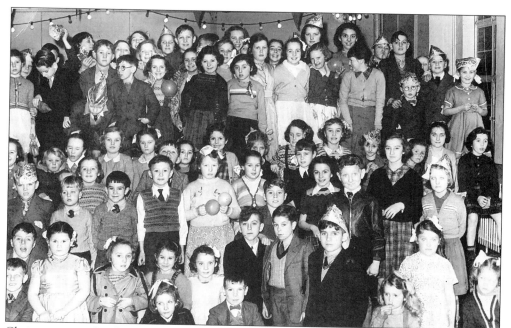

Christmas party for the children of E.M.I. social club members held in the factory canteen in 1953.

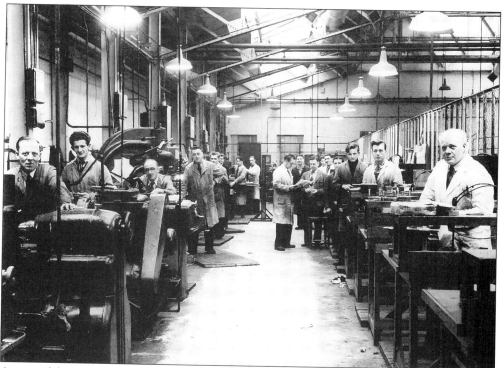

A view of the toolroom at the E.M.I. factory in Treorchy, c. 1960. From left to the right: Hubert Edward, Herbie Pugh, Harry Howells, Percy Evans, Bob Morris, Roy Woods, Ken Green, Harry Jones, Ken Jackson, Emrys Jenkins, George Woods, Dennis Cooper, Ron Pryce, Ron Jenkins, Mike Condron, Gordon Richards, Em Harrison.

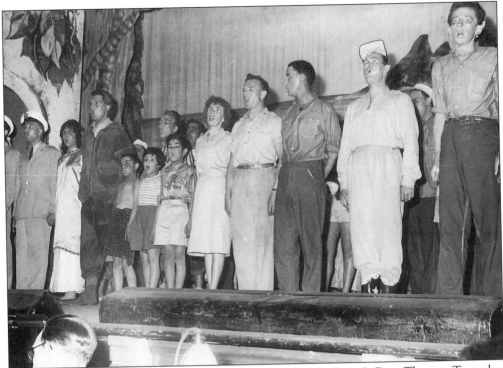

Rhondda Theatre Group's performance of *South Pacific* at the Parc & Dare Theatre, Treorchy, 1961. The producer, Morgan Jones is pictured second from the right wearing the baseball cap. The leading man, Dennis Williams and the leading lady, Joan Baxter were married a few years later!

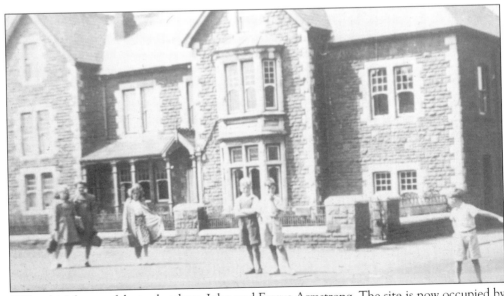

'Gilnockie', home of doctor brothers, John and Fergus Armstrong. The site is now occupied by Treorchy Central Library which was opened here in 1971.

Four

Pentre, Ton Pentre
and Gelli

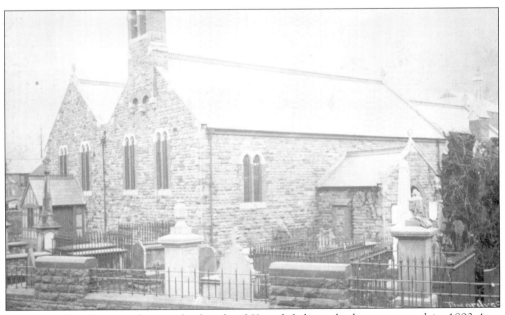

St John's, Ton Pentre, the parish church of Ystradyfodwg which was erected in 1893-4 to replace the ancient church.

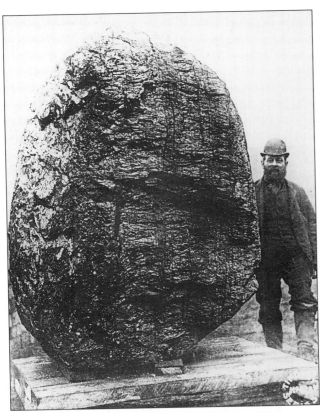

The awesome lump of coal which was hewn at Gelli Colliery and won first prize at the 'World Columbian Exposition' in Chicago, 1893.

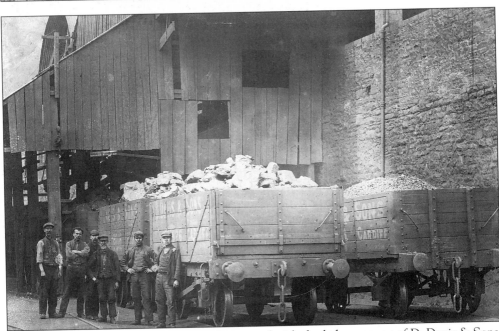

Surface workers at Gelli Colliery, c. 1910, pictured with the laden wagons of D. Davis & Sons, Cardiff. The colliery was first opened in 1877 by E. Thomas and G. Griffiths to work the steam coal measures. In 1884 it was bought by Cory Brothers of Cardiff.

David Richards, fruiterer of 33 Carne Street, Pentre. The date of the construction of this terrace (1875) is indicated by the stone in the top right-hand corner.

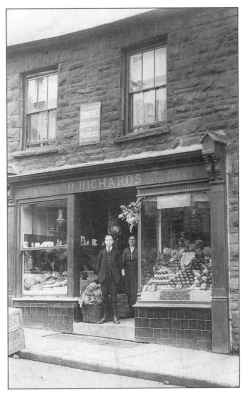

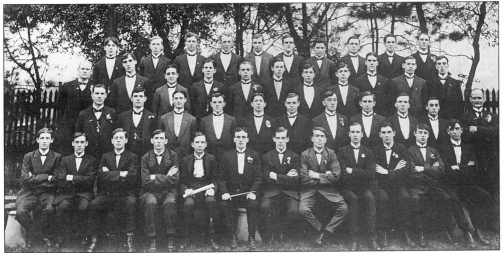

Pentre Swan Glee Society, 1915. From left to right, back row: G.I. Davies, A.G. Williams, D.H. Davies, A. Morris, T. Richards, D.W. Jones, T.B. Williams, D.H. Williams, W.J. Williams, E.J. Thomas. Third row: W. Woodward (Committee), S. Willis, D.R. Davies, G.H. Williams (Treasurer), W.R. Jones, E. Harding, J. Nicholas, C. White, T. Willis, W.Ll. Thomas, T. Rosser (Secretary). Second row: J.J. Lewis (Committee), R. Rowlands, E. Jones, G. Howells, W.J. Davies (Assistant Secretary), J. Richards, D. Evans, T.J. Price, M. Owen, W.H. Richards, T. Button (Chairman). Front row: L. Perham, W.D. Hughes, J.D. Howells, D. Jones (Vice-chairman), H. Price (pianist), D.J. Morris (Conductor), D.J. Morgan (Assistant Treasurer), F.W. Jones, M. Morris, W.C. Evans, W. Richards, B. Rowlands.

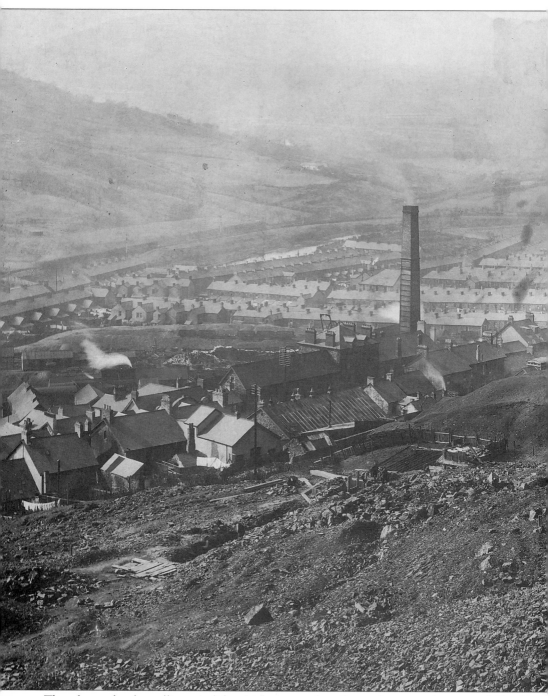

The aftermath of a colliery tipslide which occurred at Pentre between August and October 1916 demolishing shops and the Star billiard saloon. The slip which almost severed the road link between the upper and lower Rhondda Fawr valley brought home to the authorities the need to duplicate the congested and inadequate main roads and thereby help improve woeful road communications in the valley. It had originally been advocated by the trustees of the Bute estate that all main roads in the area should be at least 50 feet in width and this suggestion was

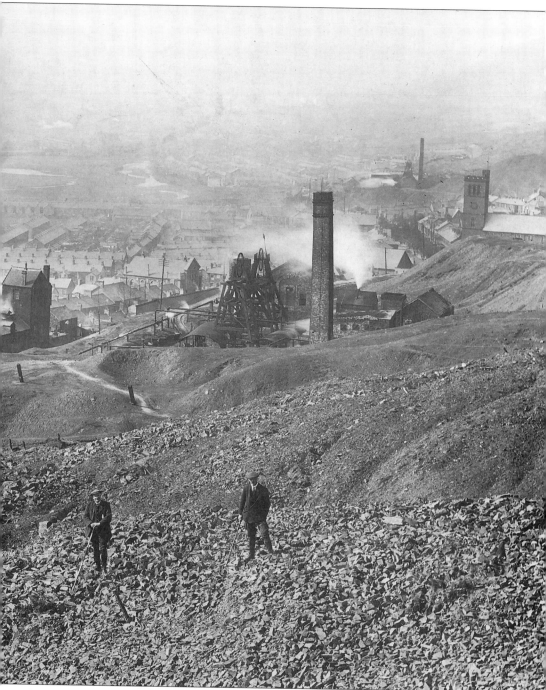

put into practice in some places, notably Treorchy. However, simple lack of space on the valley floor to accommodate both rail and broader road links and the rapid erection of thousands of roadside shops and houses resulted in the paralysis of this idea. A tortuous road transport network was thus bestowed on the Rhondda which has continued to plague development throughout the twentieth century.

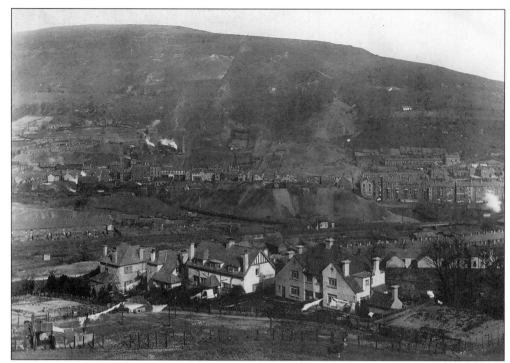

View from above the Crofts, 1918, showing the Pentre Colliery tips and the area (centre of picture) which was covered by the landslip of 1916.

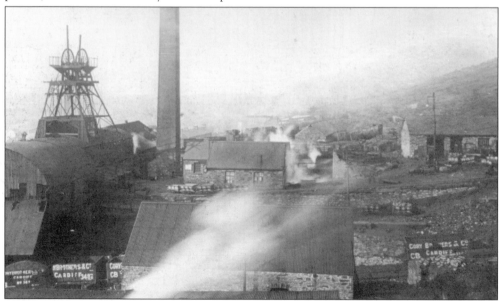

Tynybedw Colliery, Pentre, commonly known as 'the Swamp', c. 1920. It was opened in 1876 by Edmund Thomas and George Griffiths on farmland leased from Crawshay Bailey. In 1884 the Tynybedw and Gelli collieries were bought by the Cardiff coal exporters, Messrs Cory Brothers & Co. of Cardiff as part of the substantial development of their coal mining interests in this area. Earlier in 1869 Cory Brothers had purchased the Pentre Colliery and between 1874 and 1884 they almost trebled output here from 59,211 tons to 159,003 tons a year.

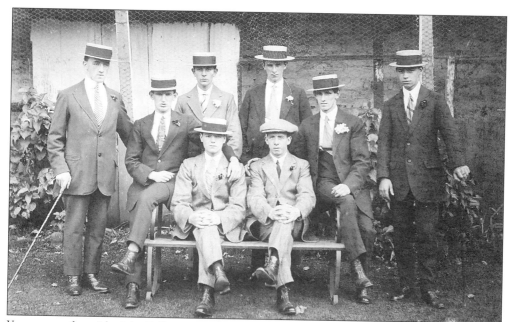

Young men from 'the Moel', Pentre, in their Sunday or evening best, *c.* 1910. Standing on the left is David Evans.

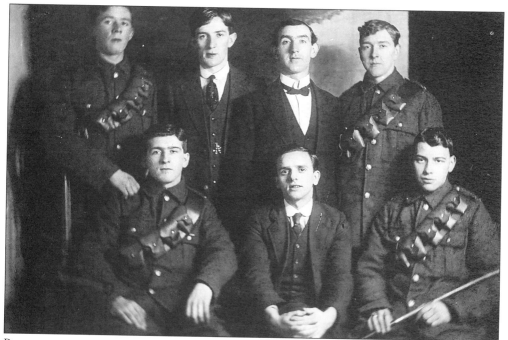

Pentre young men pictured during the First World War.

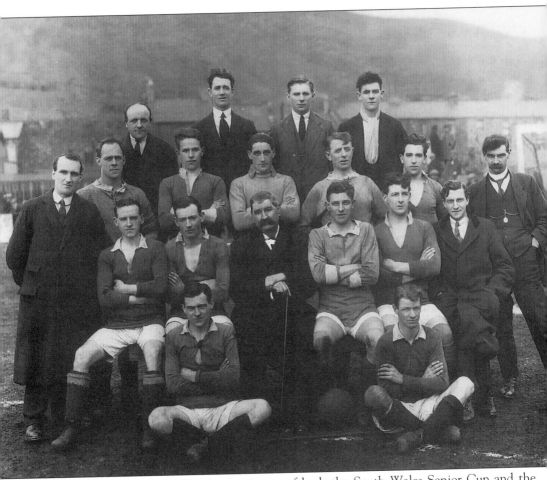

Ton Pentre A.F.C., 1921-22 season, winners of both the South Wales Senior Cup and the Welsh League three years in succession. From left to right, back row: W. Sparkes (Assistant Trainer), E. Rees, T.C. Matthews, R. Jones. Third row: Ben Evans (Hon. Secretary), C.S. Butler, C. Poynton, W.D. Reed, L. Woods, H. Jones, W. Breeze (Trainer). Second row: G.J. Nicholls, T. Adamson, J. Davies, Esq. (Chairman of Directors), A.H. Tanner (Captain), J. Jones (Vice-captain), E. Smith, Esq. (Director). Front row: W.J. Jones, H. Hunt.

Opposite: Roy Paul of Gelli, one of Rhondda's sporting greats, seen here raising aloft the F.A. Cup as captain of Manchester City, 3-1 victors at Wembley in 1956. Roy later brought the cup back to the Rhondda and took it around various schools for the children to see it. The Second World War disrupted the early part of Roy's professional football career although before he volunteered for the Marines in 1943 he had become a regular member of Swansea's War League team while continuing to work as a miner. In the 1948-49 season his dominant performances at wing half helped Swansea Town into the Second Division and he won the first of his 33 caps for Wales. After a brief flirtation with South American football, Paul was transferred in 1950 to Manchester City for a near British record fee of £25,000, becoming an influential member of a team which gained promotion to the First Division the following year and went on to cup glory. Roy's nephew, Alan Curtis certainly kept up the family footballing tradition. He was capped 35 times for Wales between 1976 and 1987.

James Patrick (Jimmy) Murphy, born at Pentre in 1910, died Manchester in 1989. He is pictured here, aged fourteen, wearing one of his two Welsh schoolboys caps won in the 1924-25 season against England and Scotland. Murphy first played competitive football at Ton Pentre Village School, later turning out for various local junior sides: Ton Pentre Boys, Treorchy Thursday F.C., Treorchy Juniors and Mid-Rhondda Utd. After losing his job as an errand boy for taking too much time off to play football, the jobless Murphy was signed by West Bromwich Albion with whom he spent the majority of his professional playing career. As an attacking wing half, he was regular fixture in the Welsh side during the 1930s earning 15 caps between 1933 and 1938. However, it is for his great work with Manchester Utd that Jimmy Murphy is best remembered. While serving in Italy during the Second World War he met Matt Busby who invited him to join United as coach, later describing him as 'my first and most important signing'. As assistant manager at the club it was Murphy who took over the reins when Busby lay injured in hospital following the Munich air crash of 1958, later leading the team

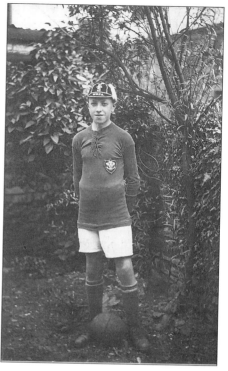

to victory in that year's F.A. Cup final on a wave of popular sentiment. As team manager and an inspirational coach for Wales (1956-64) Jimmy also guided the national team to their only appearance in the World Cup finals held in Sweden in 1958. He was to continue as assistant manager at Old Trafford until 1971, subsequently scouting for the club.

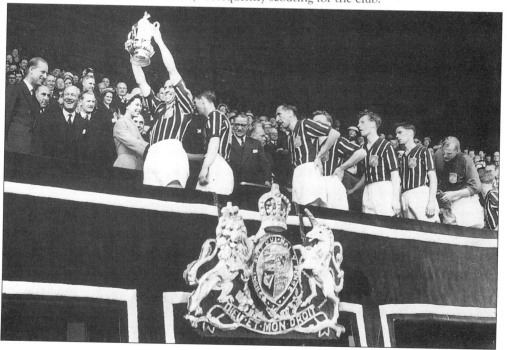

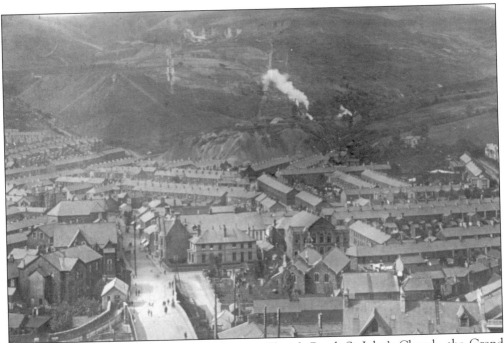

General view of Ton Pentre, *c.* 1925, showing Church Road, St John's Church, the Grand Theatre and, in the background, the Maindy Colliery.

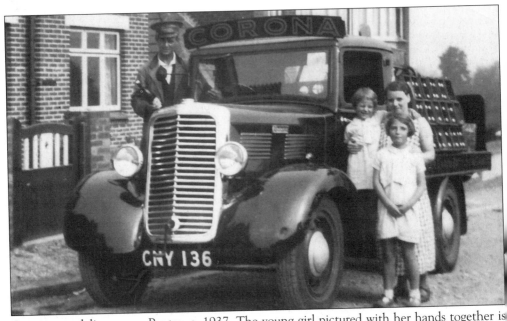

Corona pop delivery van, Pentre, *c.* 1937. The young girl pictured with her hands together is Eirwen Thorne.

Ystrad Road, Pentre, March 1938. The Popular Restaurant can be seen on the left while the poster on the far right advertises the showing at the Grand of Laurel and Hardy's new picture, *Way Out West*.

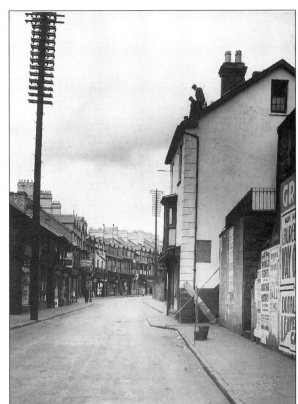

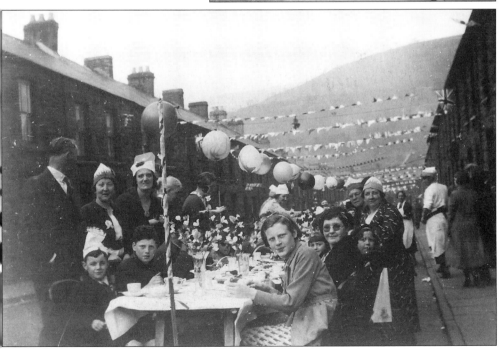

V.E. Day celebrations in Queen Street, Pentre, 1945. Standing on the far right is Mrs Gregson and second from the left, Mrs Katy Evans.

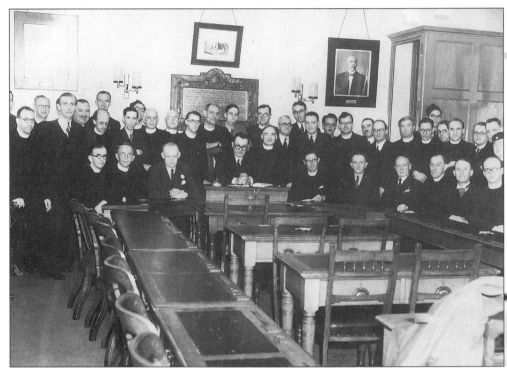

Local clergy at the Council offices, Pentre, *c.* 1947. The Chairman of the Rhondda Urban District Council for 1946-47 was Alcwyn Penry Glanville. Pictured in the front row are Revd I. Roberts (far left) and, fifth from the right, Cllr. Glyn Wales (Chairman of the R.U.D.C. 1947-48 and of Glamorgan County Council, 1972-73).

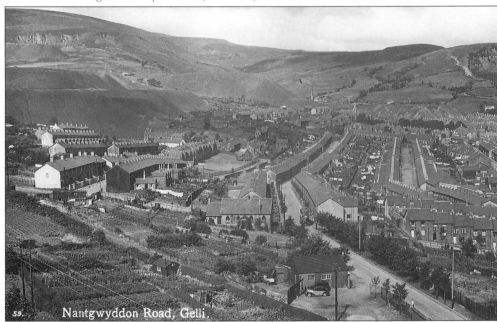

Nantgwyddon Road, Gelli, *c.* 1948. Bronllwyn School can by seen in the centre left of the picture with the spire of St David's Church, Ton Pentre in the distance.

All dressed up at Bronllwyn School, Gelli as part of the Festival of Britain celebrations in 1951.

Part of the programme for the Coronation Week celebrations in the Pentre/Ton Pentre ward of the Rhondda Urban District Council, 1953.

WARD 3 (RHONDDA) CORONATION CELEBRATIONS

THURSDAY, 4th JUNE, 1953 YNYS PARK, TON

Children's Sports

First Race—6 p.m.

PENTRE JUNIOR BOYS' v. TON JUNIOR BOYS'—9 Events
PENTRE JUNIOR GIRLS v. TON JUNIOR GIRLS'—9 events
Bronllwyn Modern Secondary BOYS' Triangular Championship
PENTRE v. TON v. GELLI—9 events
Bronllwyn Modern Secondary GIRLS' Triangular Championship
PENTRE v. TON v. GELLI—9 events
Races open to pupils, resident in Ward 3 of County Grammar and Technical Schools.

PRIZES FOR WINNERS OF ALL FINALS

Admission by Programme - Adults, 6d.; Children, 2d.

FRIDAY, 5th JUNE, 1953 LEGION HALL at 7 p.m.

Grand Variety Show

THE PICK OF WALES' LEADING ARTISTES

TOP OF THE BILL

Goldini

(Mystery—Magic—Wales' Leading Magician)

Taffy Down

A born Comedian Second to none

Trevor Morgan
Tenor, B.B.C. and Television

Rico and Raye
Popular Cross Talk Comedians

Jackie Willliams
Record Mimic
Butlin's Holiday Camp Winner

Roy Simmonds
Ace Acccordionist

R. and R.
Singing Cowboys

Not forgetting "The Negro Medley"

Special Musical Items by the

WELSH LYDIAN SINGERS

Conductor : I. Cynon Jones. Esq

Admission : 1/6 ; Children, 1/-

11

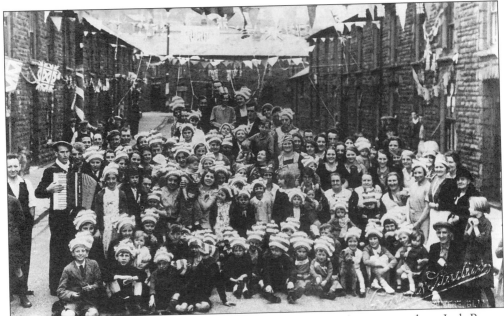

Coronation street party in Union Street, Gelli, 1953. Among those pictured are Jack Barnes (who lived at No. 8 Union Street), Dai Brace (No. 9), 'Mam' Hall (No. 22), Mrs Click (No. 23), Clarence Bacon (the accordion player), Amelia Parlour and John Kite. The church hall of St Mark's (demolished c. 1990) can be seen further down the street on the right, at the junction with Ystrad Terrace.

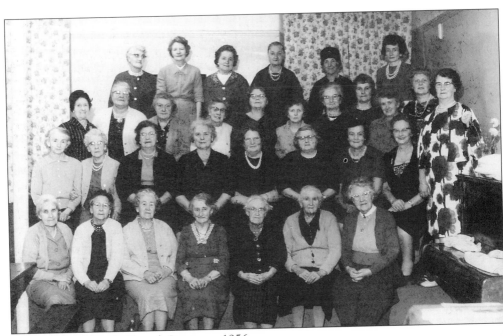

Sisterhood at Moriah Chapel, Pentre, c. 1956.

Five
Ystrad and Llwynypia

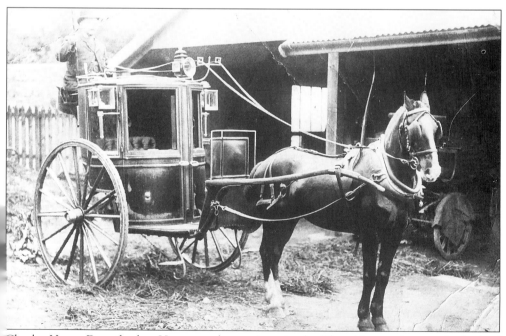

Charles Henry Doe, the last Hansom cab proprietor in the Rhondda seen here at the back of the King's Head, Ystrad.

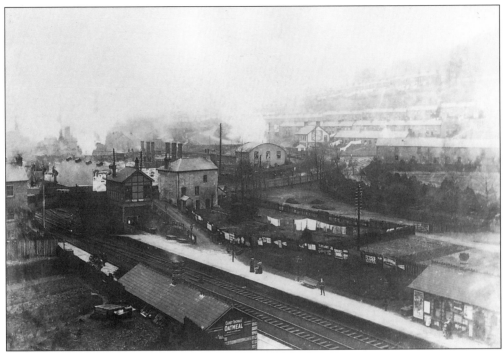

Llwynypia railway station (Taff Vale), *c.* 1900.

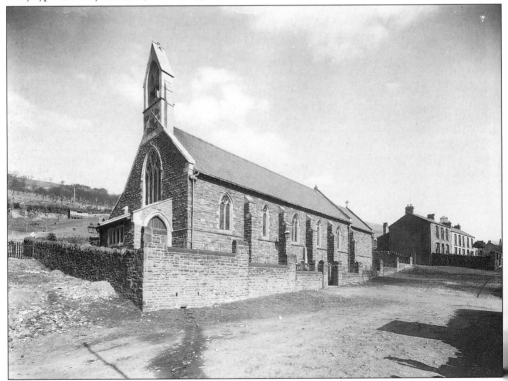

St Stephen's Church, Ystrad, viewed prior to the construction of the Penrhys road. The church
was erected in 1896 at a cost of £3,600.

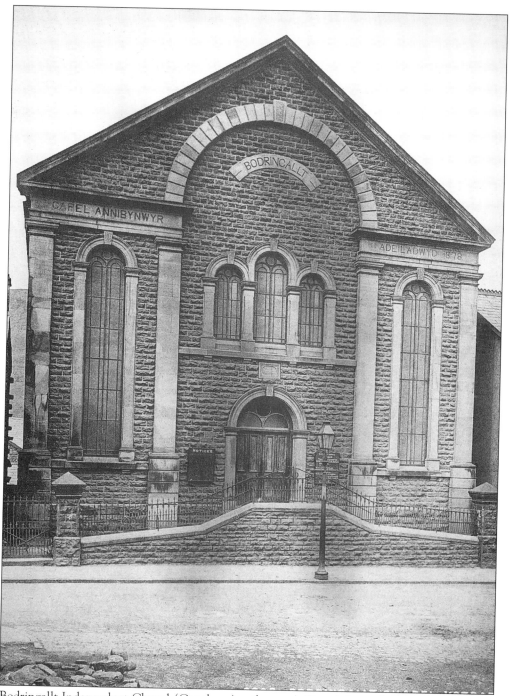

Bodringallt Independent Chapel (Capel yr Annibynwyr), Ystrad. It was built in 1878 and was one of the few Rhondda chapels to take its name from a farm in the locality.

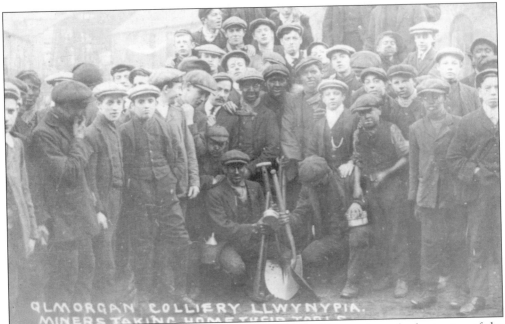

Miners taking home their tools from Glamorgan Colliery, Llwynypia at the beginning of the 'official' Cambrian Combine strike, November 1910. Llwynypia was to be the site of major disturbances on 7-8 November as striking miners, besieging the colliery in an attempt to prevent maintenance work at the pit, clashed with the reinforced police of Captain Lionel Lindsay, Chief Constable of Glamorgan. The violence resulted in serious wounding on both sides and tragically one miner died from head injuries.

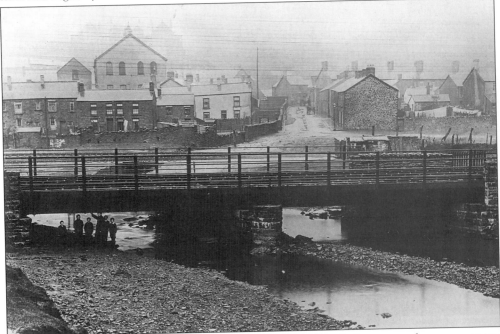

The heavily polluted river Rhondda at Ystrad, c. 1910. Brook Street can be seen, centre, leading away to Gelligaled Road.

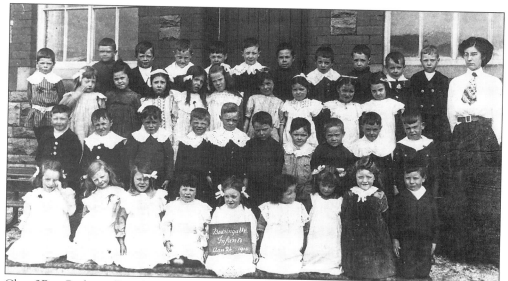

Class 2B at Bodringallt Infants School, Ystrad, 1913.

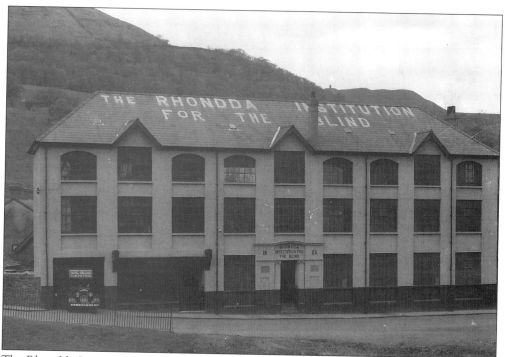

The Rhondda Institution for the Blind off Pontrhondda Road, Ystrad, *c*. 1950. It was founded here in 1923.

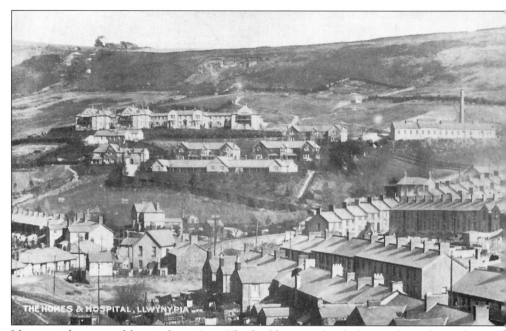

Llwynypia homes and hospital, *c.* 1914. The building on the skyline is the isolation hospital which in 1962 housed the victims of the smallpox epidemic in the area. It was later destroyed by fire to eradicate any vestiges of the disease. The homes were built as a workhouse by the local Board of Guardians between 1900 and 1904, later being converted into the first official general hospital in the Rhondda.

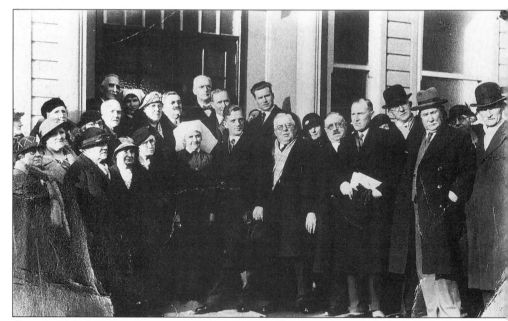

Opening of the Out Patients Department at Llwynypia Hospital, 6 February 1935. Mr Melbourne Thomas F.R.C.S., the Medical Superintendent is pictured back row, centre of picture.

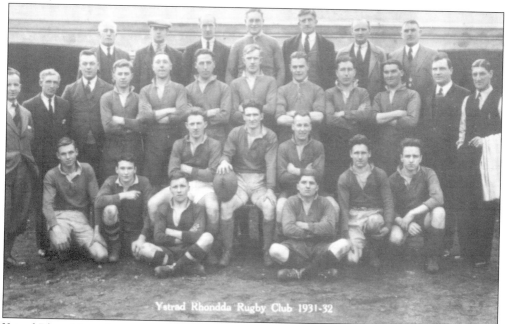

Ystrad Rhondda rugby team and officials, 1931-32 season.

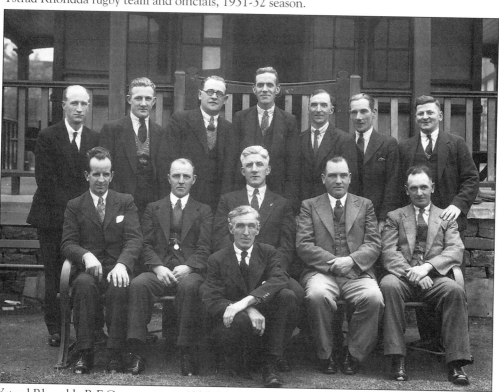

Ystrad Rhondda R.F.C. committee, 1935-36 season. From left to right, back row: A. Roach, A. Davies, D. Rees, I. Lewis, D. Whitelock, W.J. Hughes, A. Hopkins. Front row: T.S. Gibbon (Honorary Secretary), L. Roberts, T. Davies (Chairman), H.S. Davies (Honorary Treasurer), A. Morgan (Vice-chairman). Kneeling: S. Willis.

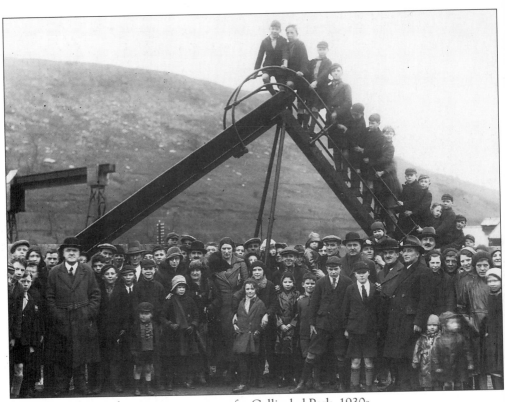

Two views taken at the opening ceremony for Gelligaled Park, 1930s.

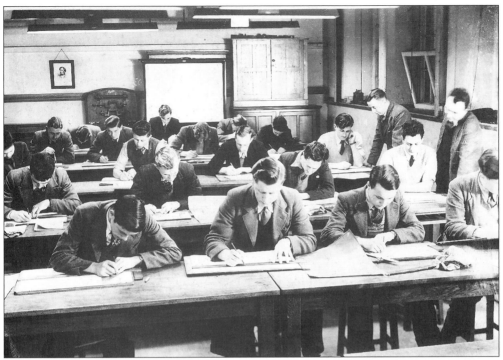

Students being taught engineering drawing at Pontrhondda Technical College, 1947.

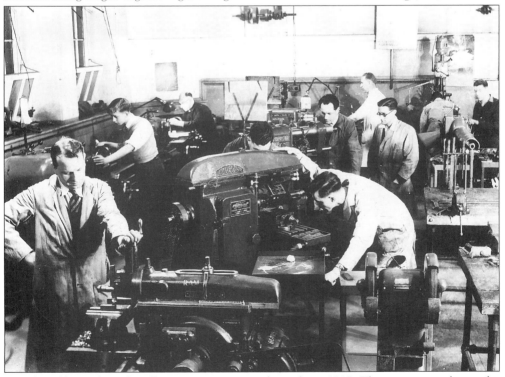

Pontrhondda Technical College engineering machine shop, 1947. The man stooped over the milling machine, centre, is Mr C. Hunt the course tutor.

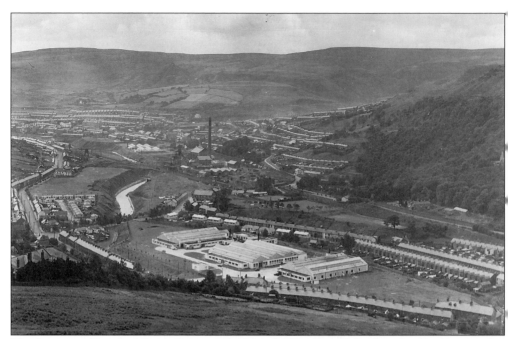

The factories of Bamford Spring Interiors Ltd; Porth Textiles and the Bramber Engineering Co. Ltd at Partridge Field, Llwynypia, *c.* 1955. These buildings were recently demolished and the land cleared to make way for a new hospital yet to be built.

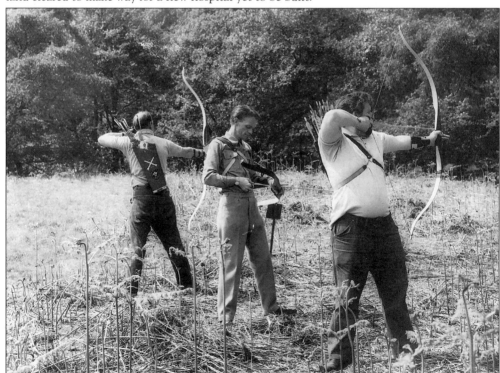

Pentref Bowmen enjoying target practice at Glyncornel, 1960s. Glan Jeffries, a founder member of the group is pictured centre.

Six

Tonypandy, Clydach Vale, Penygraig and Trealaw

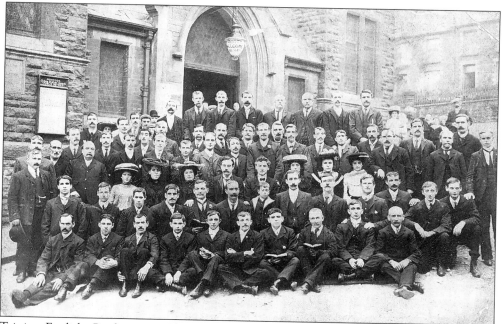

Trinity English Presbyterian Chapel, Tonypandy, *c.* 1905. The first meetings of this congregation had taken place at Richards' Coffee Tavern where an assembly room was rented at £2 a month. There, on Thursday 3 November 1887 the Revd John Pugh preached the first sermon for the church.

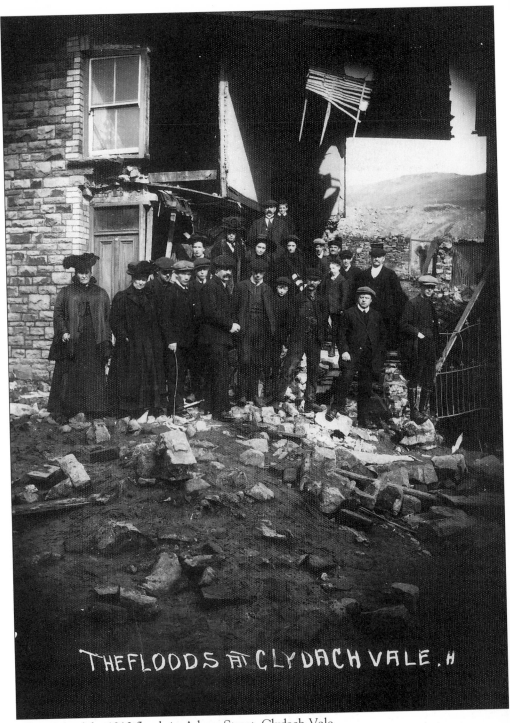

THE FLOODS AT CLYDACH VALE . H

Aftermath of the 1910 floods in Adams Street, Clydach Vale.

Tonypandy and Trealaw Library and Reading Rooms, *c*. 1905. Founded by local businessmen, this was the first free library in the Rhondda. Next door at No. 114 Dunraven Street was the Pontypridd Furnishing Company.

'Abode of Love tent' at the Mid-Rhondda Mountaineers camp, *c*. 1905.

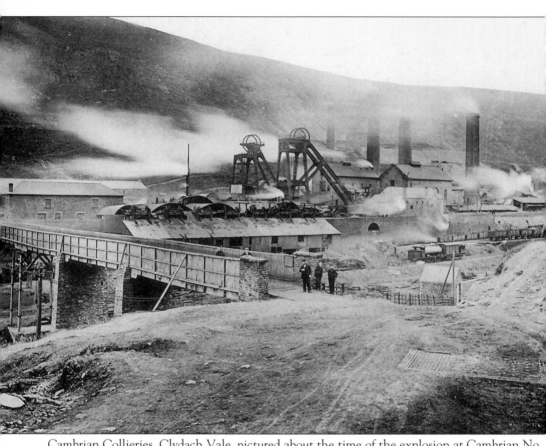

Cambrian Collieries, Clydach Vale, pictured about the time of the explosion at Cambrian No. 1 pit which claimed the lives of 33 men on 10 March 1905. In 1895 Nos. 1, 2 and 3 collieries were amalgamated here forming the initial nucleus of mines within the Cambrian Combine. Under the programme of the Welsh industrialist, David Alfred Thomas (Liberal M.P. for Merthyr 1888-1910 and later Viscount Rhondda) it was intended to 'group together the whole of the collieries producing the best Admiralty Coals'. From 1906 to 1916 the growth of the Cambrian Combine was spectacular and despite the opposition of rival coal-owners, Thomas' goal was largely achieved. In 1907 the Clydach Vale collieries were amalgamated with the Glamorgan Coal Co. Ltd's Llwynypia Nos. 1, 2 and 6 and the Sherwood Level. In 1908 the Adare Level and the Anthony, Pandy, Ely and Nantgwyn pits of the Naval Colliery Co. Ltd were taken over. Two years later a controlling interest was secured in Fernhill Nos. 1, 2, 3, and 4 and in 1916 at David Davis & Sons Ltd's Ferndale Nos. 1, 2, 3, 4, 5, 6, 7, 8, and 9. By this date the Cambrian group controlled nearly two-thirds of the total output of Rhondda mines and in addition possessed substantial interests in several other South Wales collieries as well as subsidiary industries such as railways, shipping and the import of timber. The power concentrated in the hands of the combine, for example as regards the regulation of coal prices and the wages and conditions of its workers, was thus immense and its bitter dispute with employees in 1910-11 was a crudely unequal struggle. Other coal companies were not slow to appreciate the benefits of horizontal and vertical combination and in 1908 the Ocean Company of David Davies joined forces with Wilsons, the Cardiff coal shippers, to bring under one control the production and distribution of two million tons of Rhondda Fawr coal each year. Under various names the combines forged by D.A. Thomas, David Davies and also W.T. Lewis (Lord Merthyr from 1911) controlled the Rhondda coal industry well into the 1930s and beyond, up to nationalisation in 1947.

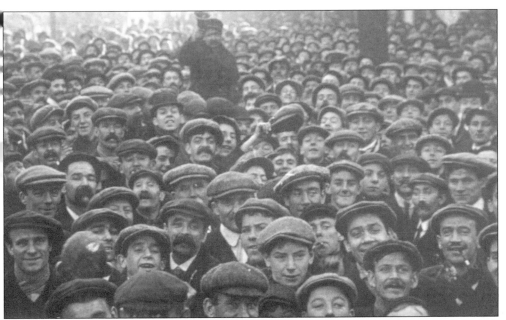

Mass meeting of colliers and pit workmen at the Empire Theatre, Tonypandy, November 1910. Here a decision was taken to initiate a policy of mass picketing of pits within the Cambrian Combine in an effort to put pressure on the owners. All management and any 'blackleg labour' would be prevented from entering colliery premises to operate pumping and ventilation machinery. This maintenance work was crucial to avoid the financial disaster of flooded workings and the real physical danger presented by the accumulation of gas.

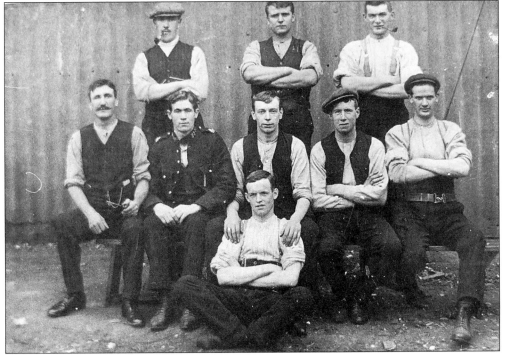

'Young Knuts' pictured at Tonypandy in 1911 during the Cambrian Combine struggle.

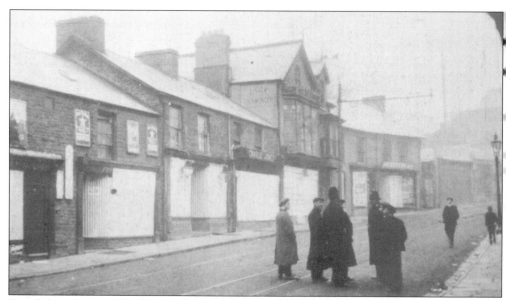

Boarded up shops in De Winton Street following the Tonypandy riots of 8 November which had seen the bitterness of some, mainly younger, striking miners against the coal owners and authorities spill over into window-smashing and looting in the commercial area of the town. Only two out of sixty shops remained undamaged: the chemist's owned by Willie Llewellyn, a member of the 1905 Welsh rugby team which had gloriously defeated the All Blacks, and a jeweller's. The protective corrugated shutters set up by the nervous trades people in anticipation of further looting gave Tonypandy the new nickname of 'zinc city'.

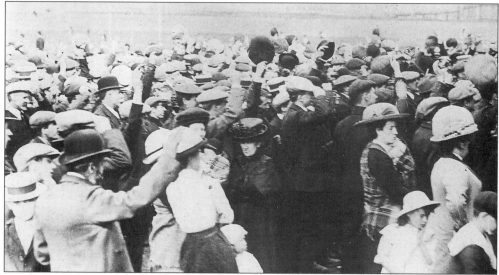

A mass gathering celebrates the return to Tonypandy in 1912 of Will John, chairman of the Cambrian Combine Workmen's Committee and John Hopla, an executive member of the 'Fed'. Following their trial at the Glamorgan Assizes in November 1911 they had both been sentenced to 12 months hard labour (later commuted to 6 months) for their part in the riots at the Ely pit on 25 July 1911 (the last major disturbance during the Cambrian Combine strike). During his absence in prison Will John was elected Miners' Agent. In 1920 he was to succeed Mabon as M.P. for Rhondda West. John Hopla died soon after his release.

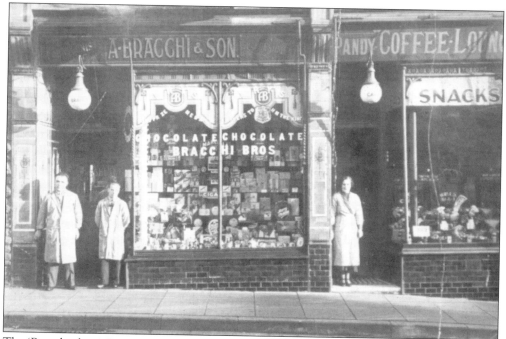

The 'Bracchi shop', De Winton Street, Tonypandy, *c. 1935*. From left to right: Ernesto Melardi (who was later to take over the business), John Davies and Mrs Woodford.

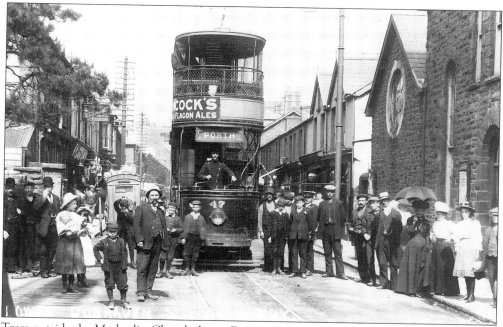

Tram outside the Methodist Church, lower Dunraven Street, Tonypandy, *c. 1912*. The church was demolished in 1923 to be replaced by the Wesleyan Methodist Hall (see page 78).

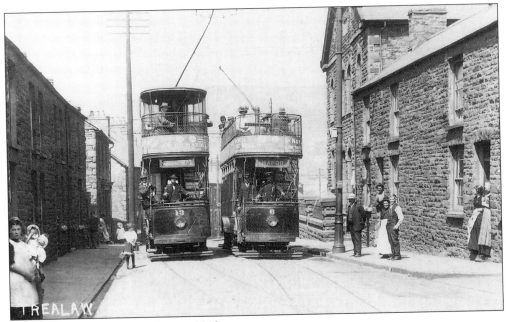

Trams in Miskin Road, Trealaw, *c.* 1912.

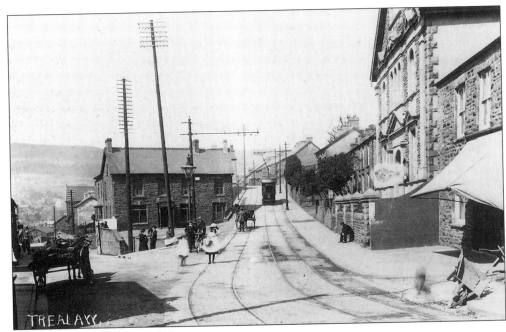

Miskin Hotel, Trealaw, *c.* 1912.

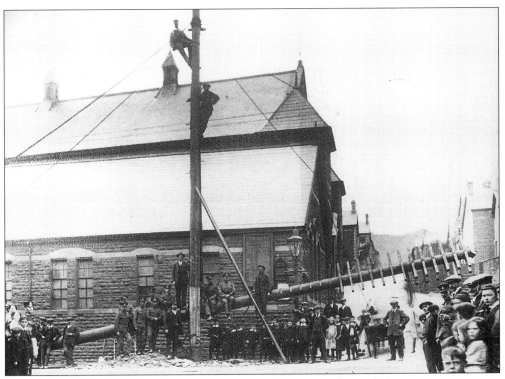

Erecting new telegraph poles outside Trinity Church, Tonypandy, *c.* 1912.

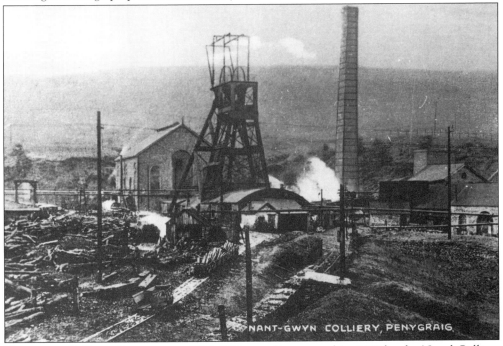

Nant-gwyn Colliery, Penygraig, *c.* 1914. This was first opened in 1892 by the Naval Colliery Company to work the steam coal seams. Tonypandy Comprehensive School now occupies this site.

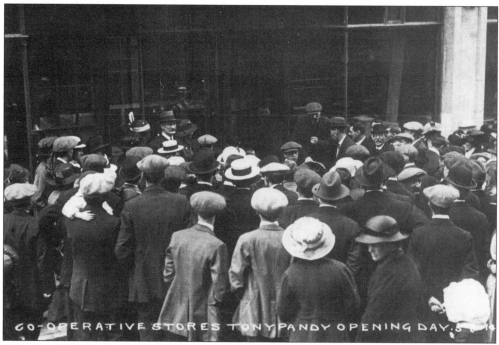

Opening of the Co-operative Stores in Tonypandy, 1914.

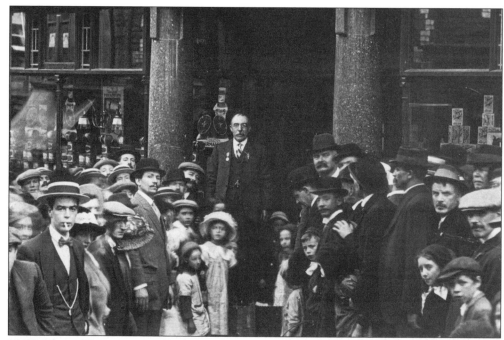

Mr Henshaw, Chairman, outside the newly-opened central premises of the Penygraig Industrial Co-operative Society, May 1914. This building replaced the old headquarters which had partially collapsed due to subsidence. As a souvenir of the event the two thousand co-op members were presented with commemorative teapots.

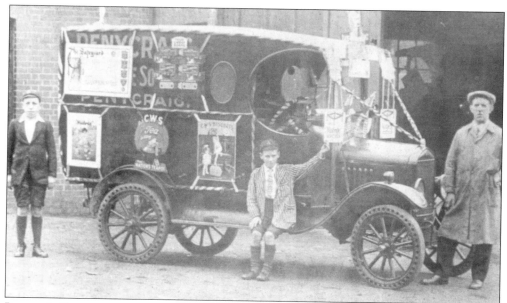

Penygraig Co-operative van, *c.* 1911. On the right is Mr Richard Henshaw while his son, David is seated on the running board.

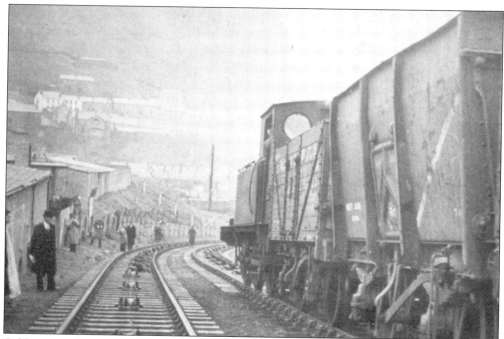

Cable assisted train descending the 1 in 13 Pwllyrhebog incline between Tonypandy and Clydach Vale, 1920s.

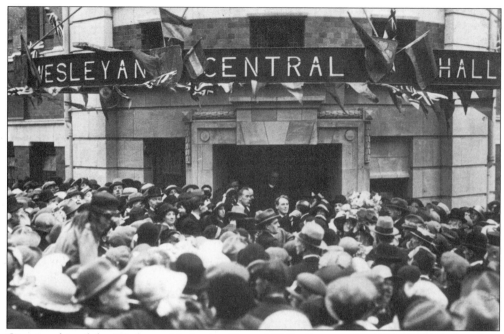

Opening day of the Wesleyan Methodist Central Hall, Tonypandy, 1923. In 1932 the three branches of Methodism were united and henceforth the building was known simply as the Methodist Central Hall. It was designed to seat 1,000 people.

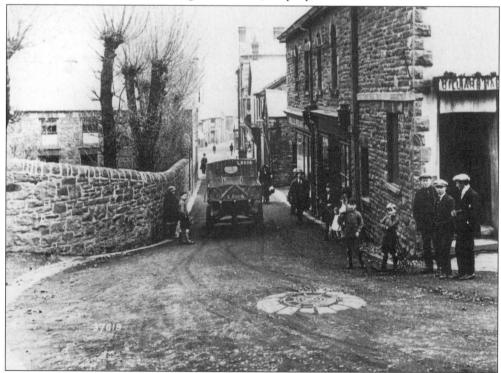

View down along Court Street towards Tonypandy Square, 1920s. The wall and buildings on the left were later removed to widen the road and thereby improve access to Clydach Vale.

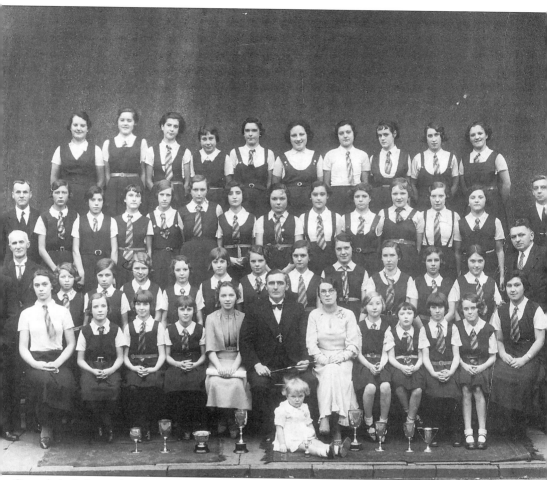

Cwmclydach Juvenile Choir, prize winners at the National Eisteddfod, 1934-35. They were conducted by Mr W. Edwards, L.R.A.M. The little girl mascot at the front is Barbara Doughty (née Davies).

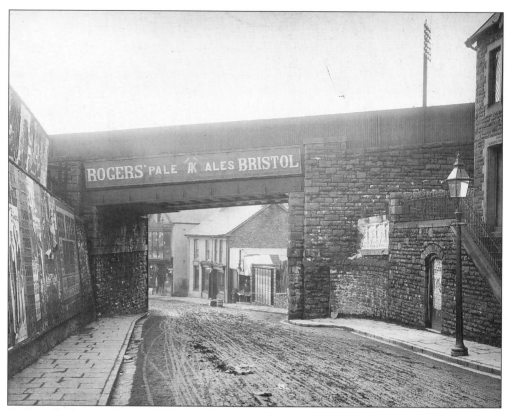

Railway bridge over De Winton Street which carried the Pwllyrhebog railway line up to Clydach Vale.

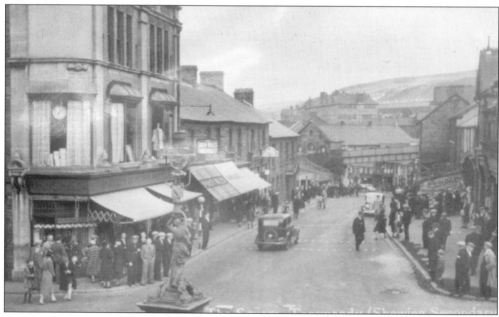

Tonypandy Square, *c.* 1947, showing the Co-op building on the left (now a doctor's surgery) and, in the distance, the railway bridge featured in the photograph above.

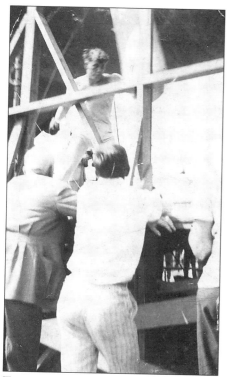

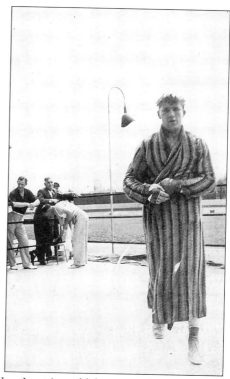

Tommy Farr in preparation for his challenge for Joe Louis' world heavyweight title, Long Branch training camp, New Jersey, 1937. On the left: Tommy and his bag work. Right: the end of the last round of a gruelling sparring session.

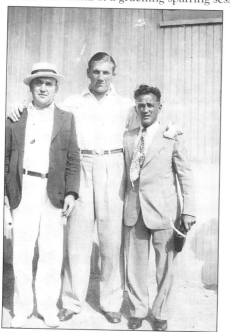

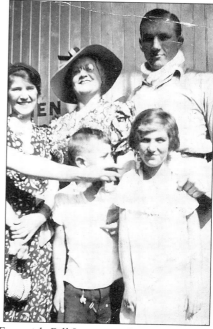

Long Branch, New Jersey, 1937. On the left: Tommy Farr with Bill Lampy and Doc Williams. On the right: 'the Welsh party' at Long Branch.

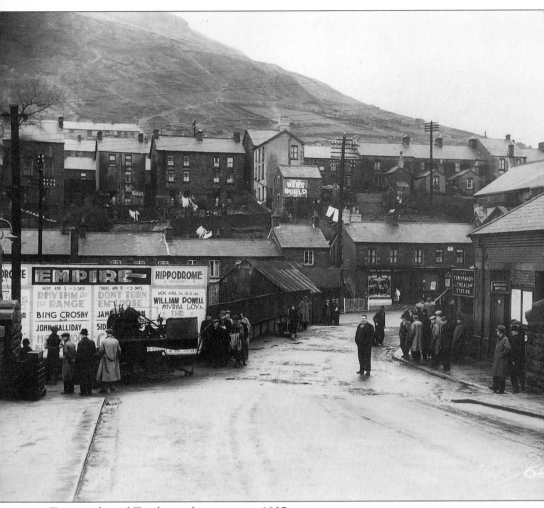

Tonypandy and Trealaw railway station, 1937.

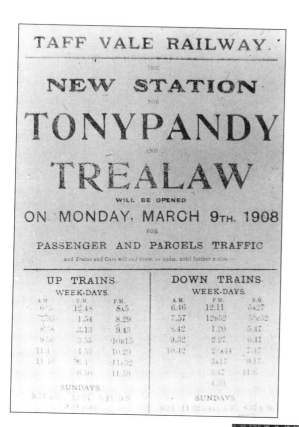

TAFF VALE RAILWAY.

THE
NEW STATION
FOR
TONYPANDY
AND
TREALAW
WILL BE OPENED
ON MONDAY, MARCH 9TH, 1908
FOR
PASSENGER AND PARCELS TRAFFIC

and Trains and Cars will call there, as under, until further notice:—

UP TRAINS. WEEK-DAYS.			DOWN TRAINS. WEEK-DAYS.		
A.M.	P.M.	P.M.	A.M.	P.M.	P.M.
6.55	12.48	8.5	6.46	12.11	5.27
7.33	1.54	8.29	7.57	12.52	5.32
8.38	2.13	9.43	8.42	1.20	5.47
9.50	3.55	10.15	9.32	2.27	6.11
11.4	4.55	10.25	10.42	2.44	7.17
11.46	5.4	11.32		3.17	9.17
	6.59	11.59		5.47	11.6
SUNDAYS.				4.31	
9.51 a.m., 12.27, 5.43, 9.9			SUNDAYS.		
p.m.			8.31, 11.32 a.m., 4.47, 8.32 p.m.		

Poster announcing the opening of the Tonypandy and Trealaw railway station in 1908.

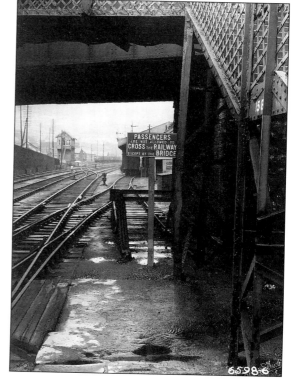

Railway bridge at Trealaw, 1937.

Visit of Rt. Hon. George Thomas M.P. (Secretary of State for Wales 1968-70, later Speaker of the House of Commons and now Viscount Tonypandy) to his old school in Tonypandy.

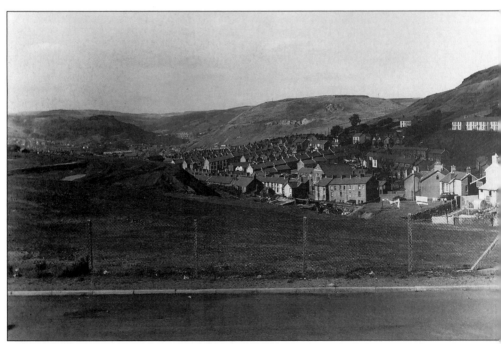

View over Williamstown, 1961, showing the Ely tip to the left.

Seven

Porth, Dinas and Trehafod

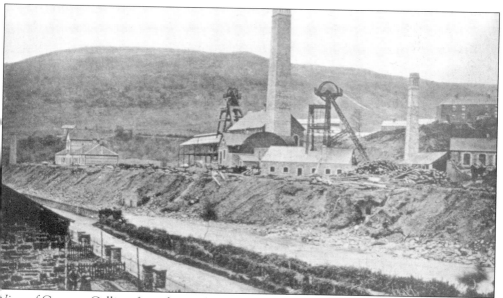

View of Cymmer Colliery from the south, *c.* 1880. This was opened in 1877 by G. Insole & Son to work the steam coal seams.

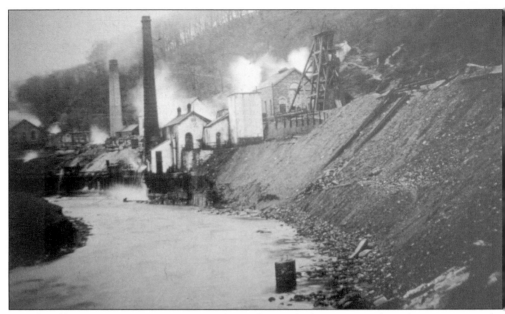

Hafod Colliery, *c*. 1920. This was opened together with the Bertie and Trefor pits in 1881 by W.T. Lewis (later Lord Merthyr).

The 'up' platform at Dinas railway station, *c*. 1920.

Two 1921 views of a now vanished section of Trehafod Road. The houses have long since been demolished and the area is now covered by the bypass around the village. The main railway line to Pontypridd passed around the backs of the terrace and washing therefore had to be dried 'out front' as illustrated. To the right of the line of children above was the workshop of Tom Angel, undertaker. In the picture below Powell's shop, later a garage, is clearly visible.

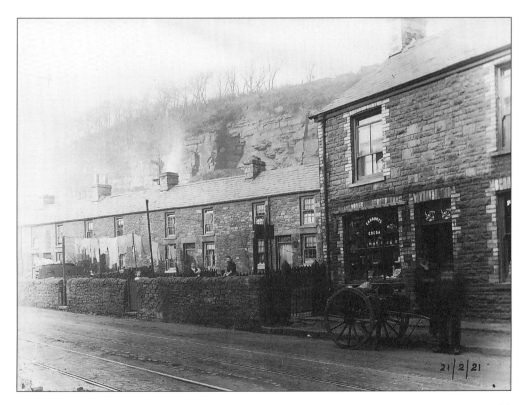

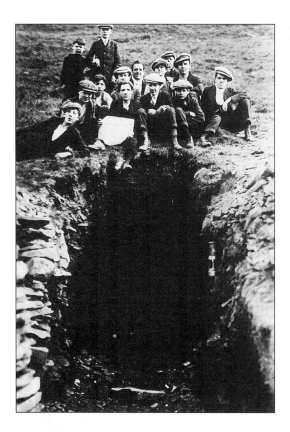

Rainbow Level, near Porth, 1920s.

Co-operative Ladies Guild, Porth, 1920s

Rhondda Tramways staff outing to Porthcawl, 1920s. In 1902, despite strenuous opposition from the Taff Vale Railway, the Rhondda Urban District Council had obtained the power to construct and operate a tramway system in the two valleys and on 14 April 1906 the Rhondda Tramways Company Limited was incorporated and an agreement was made with the National Electric Construction Co. Ltd to build and equip the new tramways.

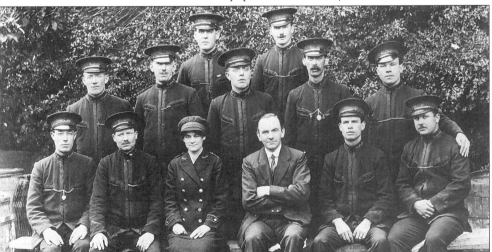

Rhondda Tramways staff, c. 1923. On 11 July 1908 tramways between Trehafod and Partridge Road (Rhondda Fawr) and Pontygwaith (Rhondda Fach) were opened. At first 50 tramcars were to be in operation on 5 w Q miles of track, employing about three hundred men; by 1 September 1908 567,638 passengers had been carried despite the fact that due to delays in the set up of the electricity generating plant only ten tramcars could initially be run. The tramways, which by 1912 had been extended throughout the two valleys, opened up the area and the 'white knuckle ride' they often provided became a feature of Rhondda life and culture. Stories are told of illegal betting operations based on the number of the first tram to emerge on Sunday morning and the subsequent 'nobbling' of trams on Saturday night since the 'last in, first out' rule also applied at the depot.

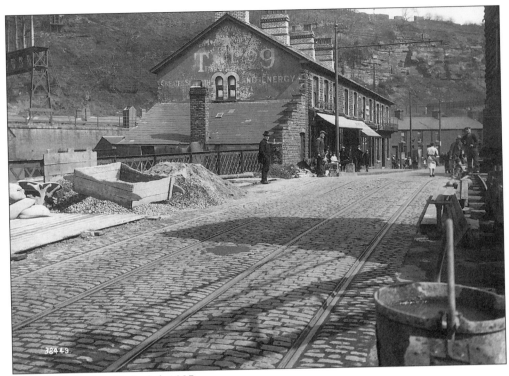

Lower Eirw Bridge, Trehafod, 1927.

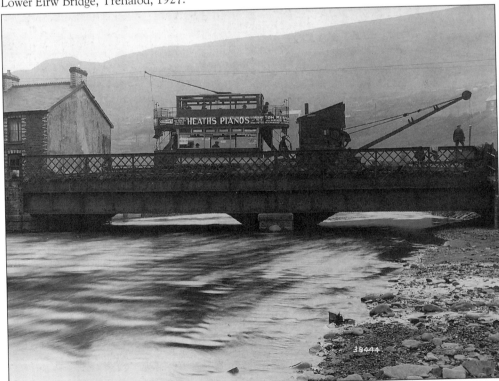

Looking downstream to Lower Eirw Bridge, Trehafod, 1927.

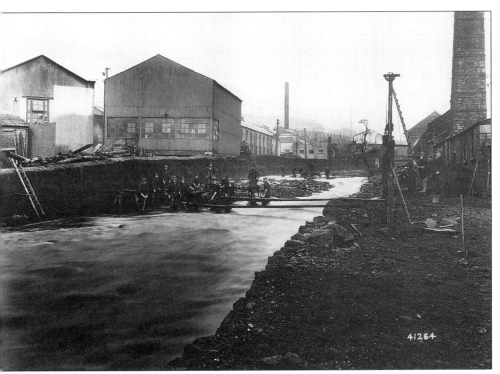

Workmen clearing the river, Rheola, Porth, 1930.

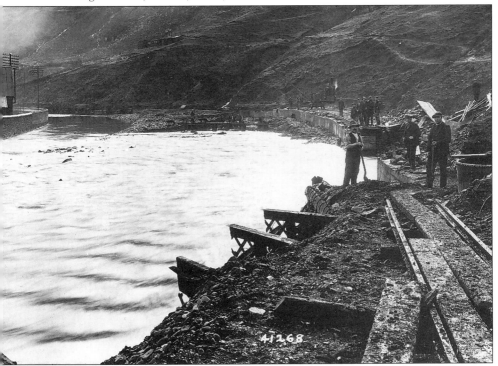

View downstream showing work underway on the construction of a concrete block wall along the river at Trehafod, 1930.

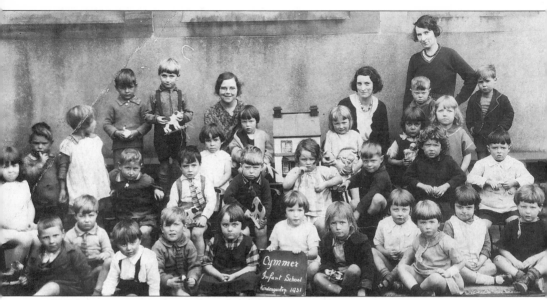

Kindergarten at Cymmer Infants School, 1931.

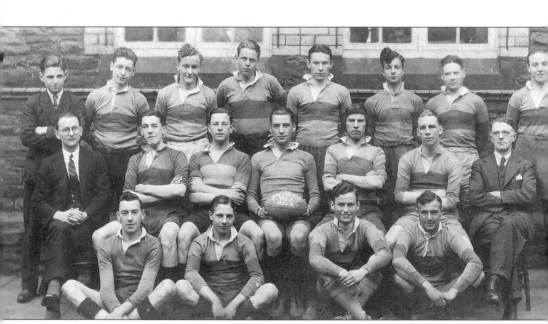

Porth R.F.C., 1932-33 season.

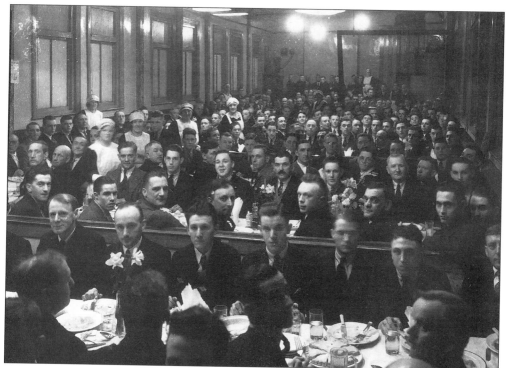

Christmas dinner for Rhondda Transport staff, 1930s. The last tram in the Rhondda ran on 1 February 1934 and in June that year the name of what had now become a bus company was changed to the Rhondda Transport Co. Ltd with a fleet then numbering 106 vehicles. Many of the above men would therefore have been employed 'on the buses'.

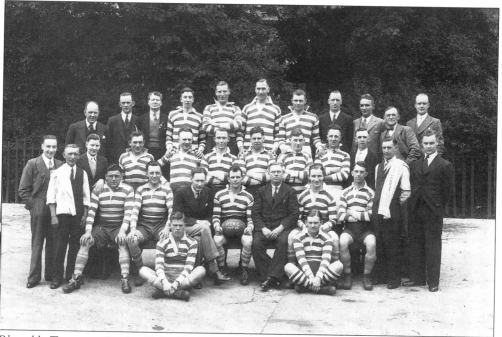

Rhondda Transport Rugby Club, 1935-36 season.

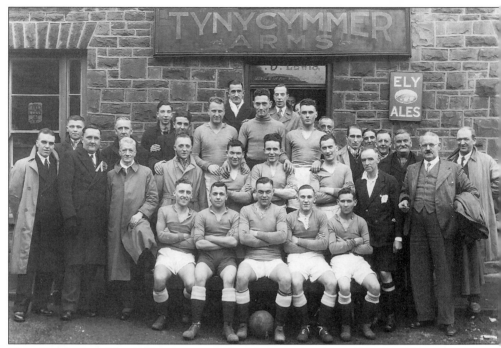

Rhondda Transport football team outside the Tynycymmer Arms, Dinas, 1930s.

Opening of Porth swimming pool, Bronwydd Park, *c.* 1936. At this time there were three othe public open air swimming baths in the Rhondda: at Gelligaled Park, Ystrad, in Darran Park Ferndale and at the Park, Treherbert. At Wattstown there was a further pool, run under the auspices of the Miners' Welfare Fund.

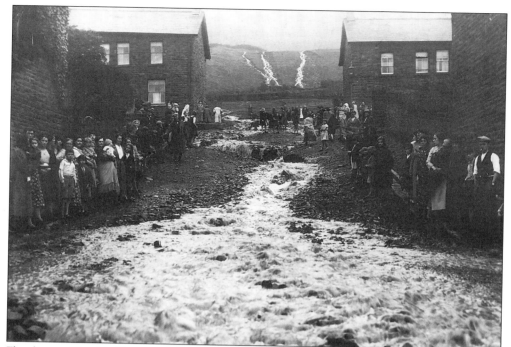

Flooding at Rheolau Terrace, Trehafod, 8 p.m. Wednesday 19 July 1939. The torrential storm, which led to flash floods cascading off the mountainside, started at 4 o'clock and finished at 6 p.m.

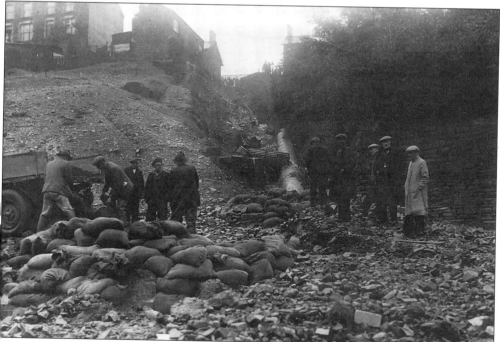

Mopping-up operations further down the hillside at Trehafod, Thursday 20 July 1939. Top left, on the corner of Pleasant View, is the Terry Stores which just survived being swept away in the floods.

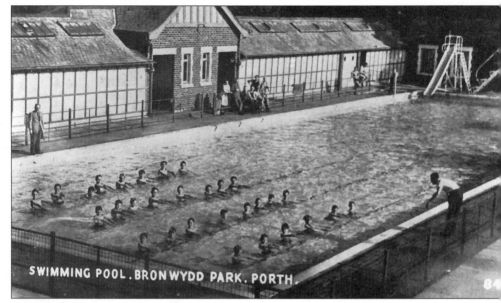

SWIMMING POOL. BRONWYDD PARK. PORTH.

Schoolboys receiving swimming lessons at Porth baths, *c.* 1943. Pupils marched from the County and Secondary schools to the pool and if your class had swimming first lesson you would be in the icy waters by 9.30 a.m. Enough to freeze the little bits off a brass monkey!

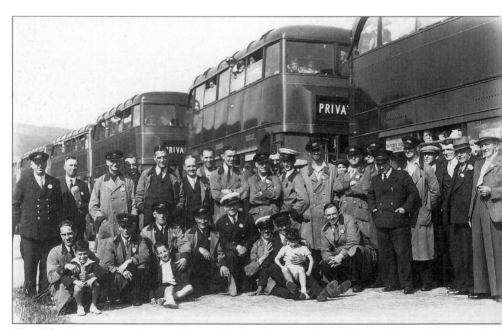

Rhondda Transport staff, *c.* 1950 with behind a new fleet of buses from A.E.C. Southall preparing to leave on a children's outing.

Presentation by the Rhondda Transport Company to driver Tom Hanley for forty years service to the organisation.

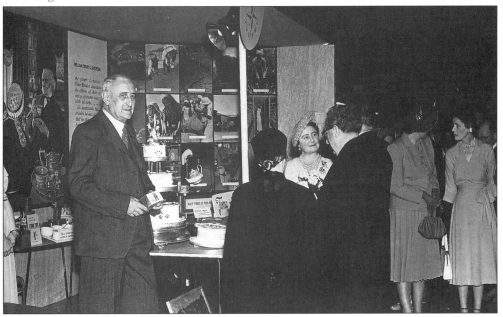

Thomas & Evans' trade stand at the Welsh Industrial Fair in Sophia Gardens, Cardiff, 1951. From left to right: James R. Whalley (tea taster and blender), Mrs W.D. James, H.R.H. Queen Elizabeth, W.D. James (new Chairman of Thomas & Evans Ltd and Managing Director of the Company since 1940). The tea blending division of the T. & E. 'empire' was based at Jenkin Street, Porth and during the Second World War the warehouse here handled not only its own tea trade but also that of many London firms. As part of the wartime zoning system 20 to 25 tons of tea a week were sent to Porth for blending and subsequent distribution all over England and Wales.

Sections and Services

• Grocery Branches

Rhondda Area

Porth
Tonypandy
Ferndale
Pontygwaith
Treorchy
Ystrad
Pentre
Treherbert
Tylorstown
Ynyshir
Maerdy
Llwynypia
Trehafod
Williamstown
Dinas
Wattstown
Trealaw
Penygraig
Blaenclydach
Stanleytown
Gelli
Heolfach
Cwmparc
Edmondstown
Clydach Vale

Pontypridd and District

Taff Street, Pontypridd
Norton Bridge, Pontypridd
Treforest
Rhydyfelin
Tonyrefail
Treharris
Taffs Well
Nelson
Ynysybwl
Abertridwr
Evanstown
Pontyclun
Pencoed
Porthcawl
Llanbradach
Caerphilly
Cowbridge
Nantgarw
Maesteg
Abercynon
Tynant
Llantrisant

Cardiff (23 Branches)

2 Mobile Shops
Penarth

• Self Service Stores

131 Station Road, Llandaff North. Tel: Whitchurch 11.
234 Cowbridge Road, Cardiff. Tel: Cardiff 26755.
3 Heol-y-Deri, Rhiwbina. Tel: Rhiwbina 241.

• Confectionery Branches

Porth Pontypridd
Cardiff Cowbridge
 Aberavon

• Meat Department

Cooked Meats Factory—rear 8/9 Hannah Street, Porth.
Cooked Meats Shop—22 Hannah Street, Porth.
Butchery Shop—24 Hannah Street, Porth. Tel: Porth 181.

• Bakeries

Garden City Bakeries, Ely, Cardiff. Tel: Llandaff 317.
Jenkin Street, Porth. Tel: Porth 181.
Dunraven Bakery, Bridgend. Tel: Bridgend 211.

• Vinegar Brewery

Barbourne Brewery, Worcester. Tel: Worcester 4581.
Glandwr Bottlery, Porth.

• Tea Blending

Jenkin Street, Porth. Tel: Porth 181.

• Hardware Department

16/17 Hannah Street, Porth. Tel: Porth 181.

• Drapery Department

19 Hannah Street, Porth. Tel: Porth 181.

• Engineering Department

Jenkin Street, Porth. Tel: Porth 3.

• Printing Department

Cymmer Bridge, Porth. Tel: Porth 181.

• Box Making Department

Cymmer Road, Porth. Tel: Porth 3.

THOMAS & EVANS LIMITED

Head Office Hannah Street, Porth. Tel: Porth 181

The extent of the business built up by Thomas & Evans Ltd in the decades following the company's foundation in 1885 is clearly illustrated in this page from the official booklet celebrating 70 years of continuous operations. In addition to the above services and manufacturing, there was an extensive chain of 'Corona' factories and depots throughout England and Wales producing and distributing the range of popular 'family drinks': fruit squashes, cordials and sparkling beverages. The success of the company was eventually to attract the attention of larger players in the food and drink industry, leading to the takeover of Thomas & Evans by the Beecham group, and the loss of the trading name so familiar to generations of Rhondda shoppers.

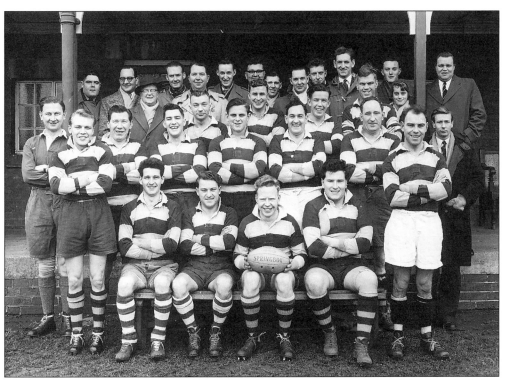

Rhondda Transport R.F.C., 1954. Holding the ball is Don May and seated first on the left is Ron Bacchetta.

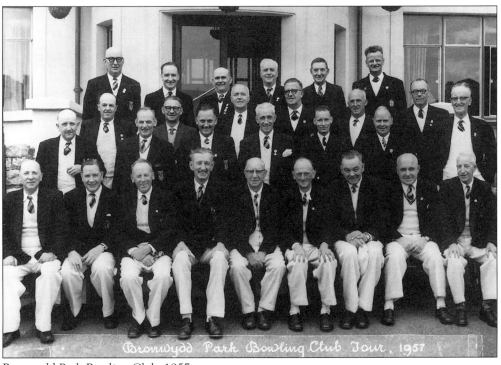

Bronwydd Park Bowling Club, 1957.

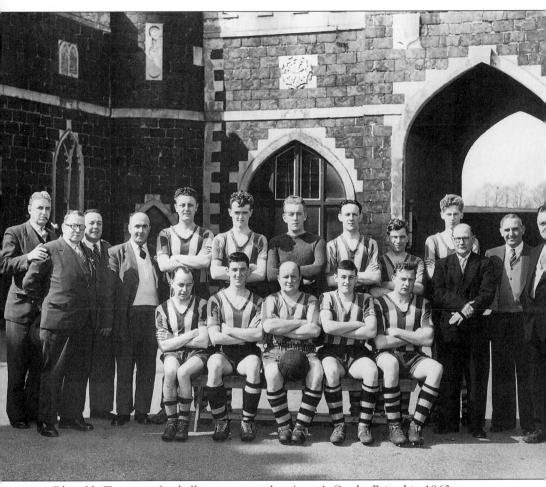

Rhondda Transport football team pictured at Arnot's Castle, Bristol in 1962.

Eight
Ynyshir, Wattstown, Pontygwaith and Tylorstown

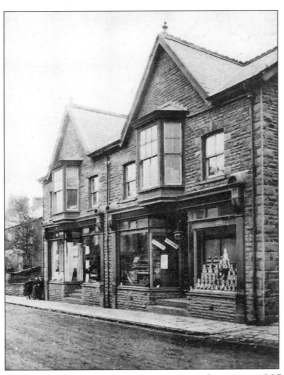

Ynyshir and Wattstown Co-operative Stores, *c.* 1905.

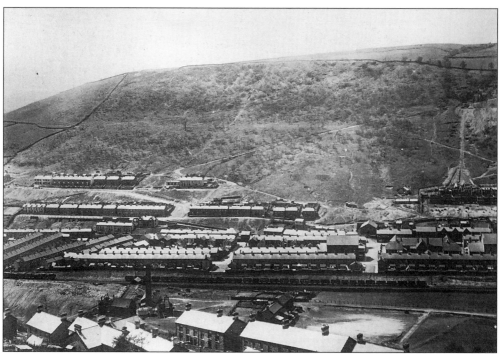

General view over Ynyshir, *c.* 1900.

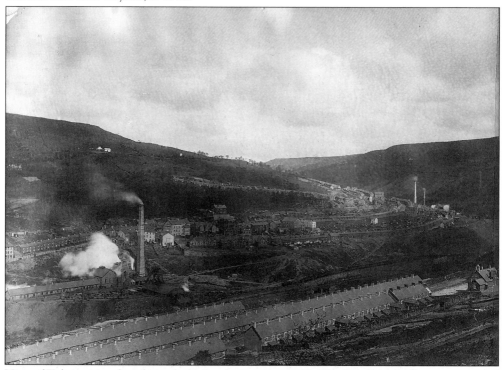

View of Tylorstown taken from above Stanleytown, *c.* 1900. The Pendyrus Colliery was opened here in 1873 by Alfred Tylor, from whom the village took its name. Tylorstown School can be seen in the centre of the picture with Stanleytown School on the extreme right.

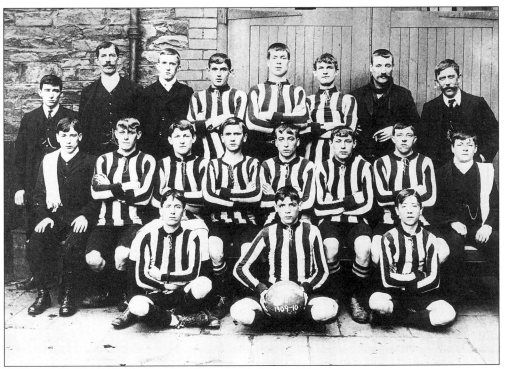

Tylorstown Albions football team, 1909-10 season.

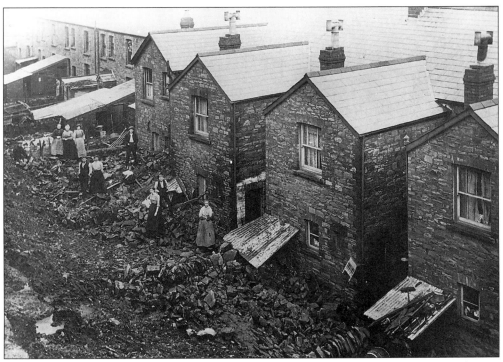

Landslide in Tylorstown, *c.* 1910, which caused the collapse of a wall by Brynbedw Road.

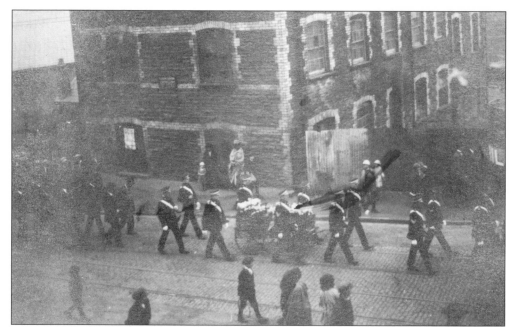

Funeral of a member of the ambulance brigade, 1912. In the background is the Fernvale Brewery, Pontygwaith.

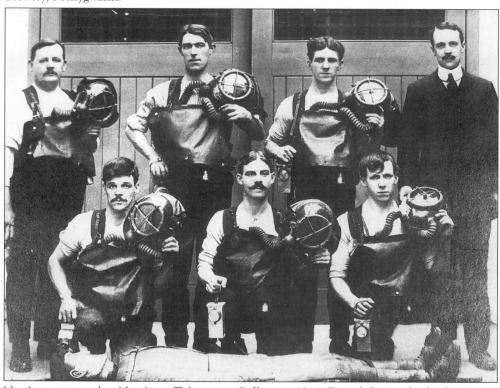

No. 1 rescue squad at No. 6 pit, Tylorstown Collieries, 1914. From left to right, back row: Mr W.E. Emerson M.E. (Captain), H. Davies, Daniel Roberts, Superintendent Thorne. Front row: T. Gomm, Cornelius Gronow, Robert Roberts.

Portrait of a local family taken by the photographic studios of A.E. Duffey in Pontygwaith, *c.* 1910.

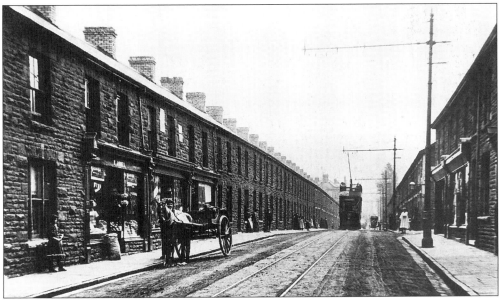

Llewellyn Street, Pontygwaith, *c.* 1914.

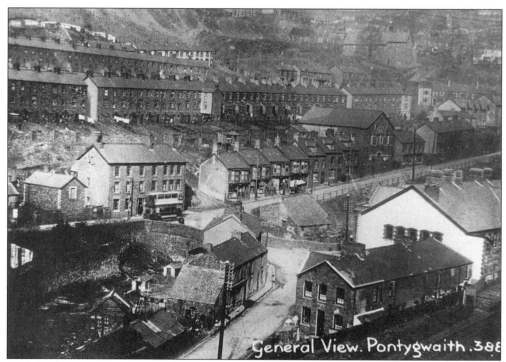

View over Pontygwaith, *c.* 1920.

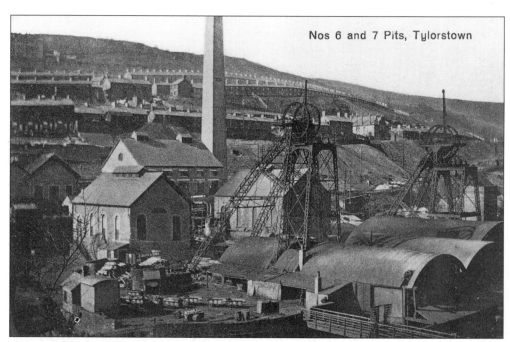

Nos. 6 and 7 pits, Tylorstown, *c.* 1920. Note the development of the colliery which has taken place since the photograph on p.102 was taken.

Elwyn, Betty and 'Mam' Hughes, East
Street, Tylorstown, *c.* 1922.

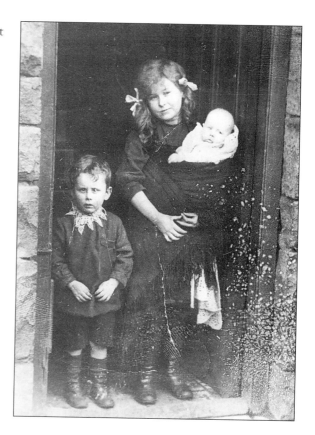

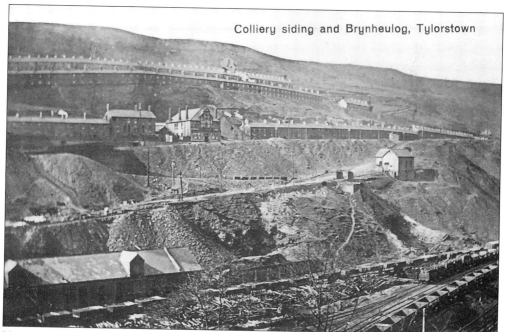

Colliery siding and Brynheulog, Tylorstown

View over Brynheulog, Tylorstown with the colliery sidings in the foreground, *c.* 1920.

Main entrance of the Eagle Hotel, Ynyshir, 1930.

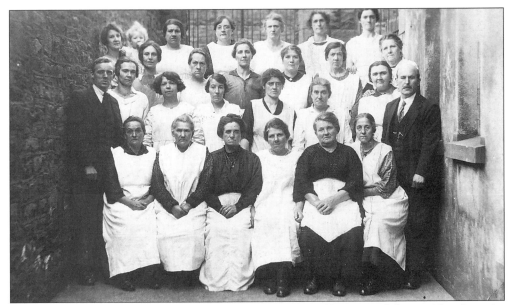

Female staff at Moriah Chapel canteen, Tylorstown, probably pictured during a break in the work of running a soup kitchen for miners and their families during the 1926 strike.

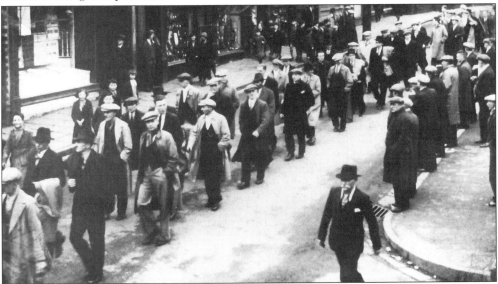

March against unemployment passing through Tylorstown, c. 1936. Such was the seeming hopelessness of the area's plight that at the low point of the Depression a Welsh cabinet secretary wrote that the best solution for the Rhonddas would be to build a dam and flood the area so that a least they could produce hydroelectricity. This lack of sympathy for the people of the Rhondda was evident too at prime ministerial level when Ramsay MacDonald is reputed to have told a delegation from the valleys: '[solve] your unemployment problem by the removal of these tips'. Although some measures were taken in the late 1930s to provide new sources of unemployment under the Special Areas Act (e.g. the huge new trading estate that was established at Treforest and the Polikoff clothing factory at Treorchy) it was not until after the Second World War that the Board of Trade under a Labour government promoted the establishment of a string of new factories up and down the two valleys (see p.66).

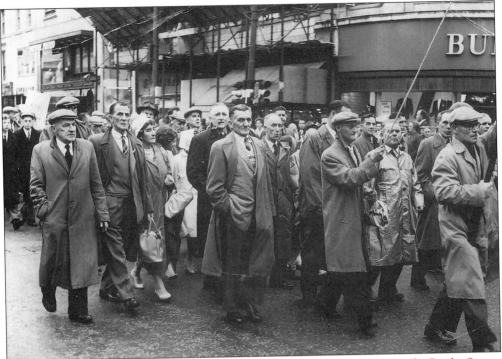

Ynyshir and Wattstown miners, their wives and families marching through Castle Street, Cardiff on the way to hear Michael Foot M.P. and other well known speakers address a gala of miners from all over South Wales, c. 1960. The lady in the white mac, below, is Rose Griffiths of William Street, Ynyshir.

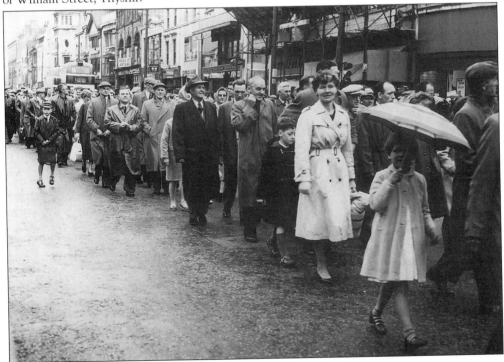

Collapsed bridge wall at Tylorstown, March 1947, with the power station in the background.

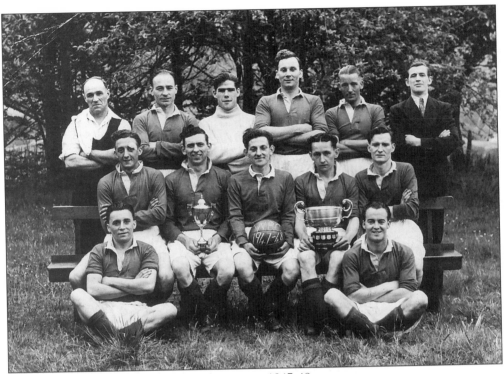

Wattstown Boys' Club football team, champions, 1947-48 season.

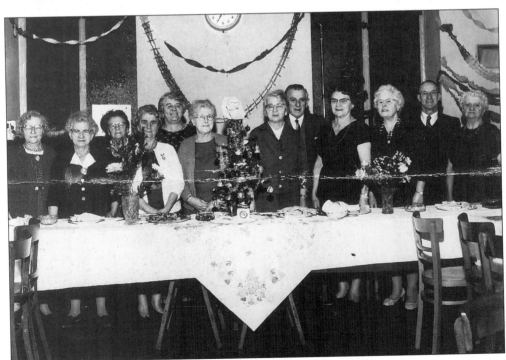

Ynyshir No. 1 O.A.P. Association at the Lesser Hall, Ynyshir, *c*. 1950.

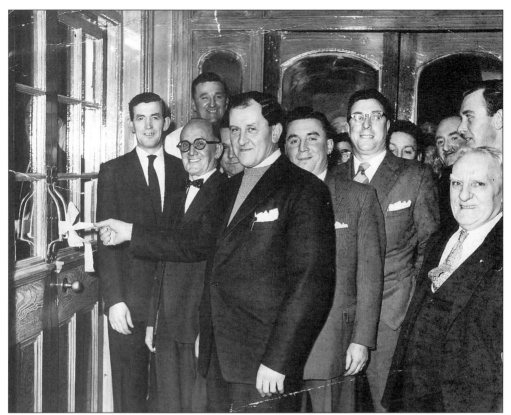

The opening ceremony held at Wattstown Institute when part of the building became a licensed club, *c.* 1950. Will Whitehead 'does the honours'.

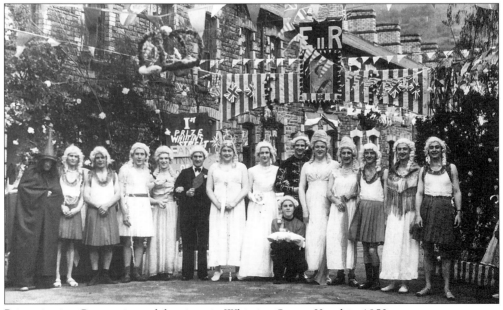

Prize winning Coronation celebrations in Whitting Street, Ynyshir, 1953.

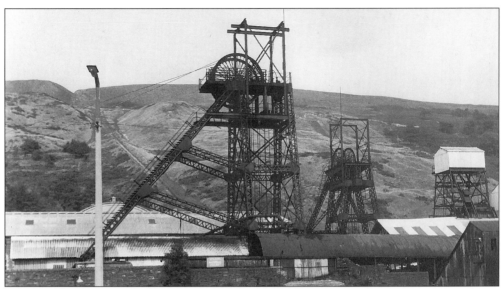

Wattstown Colliery, 1960s. The No. 1 and No. 2 National collieries were opened at Wattstown in 1881 by Ebenezer Lewis, Henry Lewis and Mathew Cope.

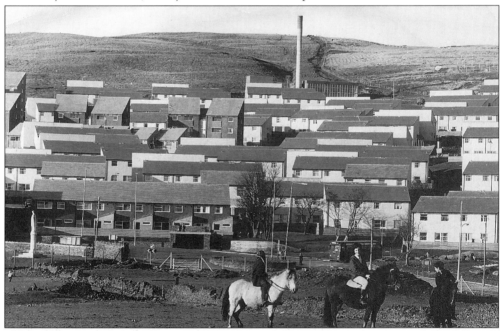

View over the Penrhys estate, c. 1970. Planned in the mid-1960s, it was felt that the attractive hilltop location and new housing of Penrhys would help prevent the drift of population out of the two Rhondda valleys and perhaps also attract new immigrants to the area. However, the initial optimism soon vanished as the realities of the exposed mountain top position became evident. Early deterioration of the buildings further discouraged new residents and rapidly Penrhys became a high turnover estate where because of abundant vacancies it was easy to place the most underprivileged and problematic families. The Penrhys of infamy was soon born. Nevertheless, despite the complex problems a community has been constructed and recent years have seen improvements in the quality of life for its residents.

Nine
Ferndale and Maerdy

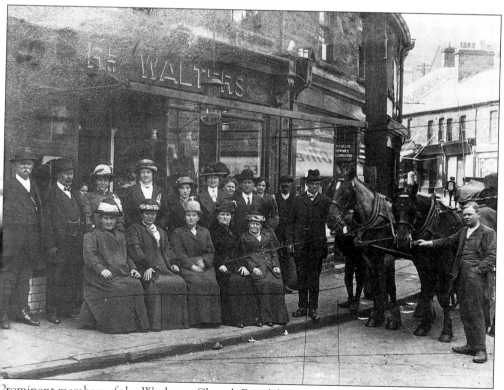

Prominent members of the Wesleyan Chapel, Ferndale, *c*. 1905.

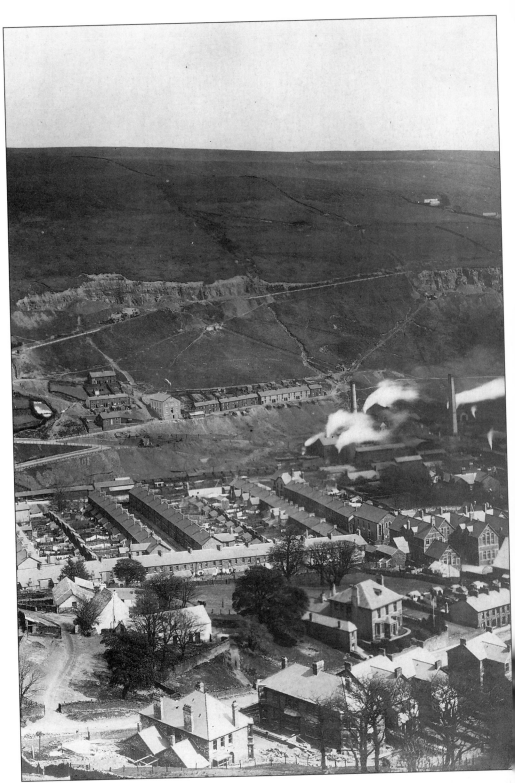

View of Ferndale, *c.* 1900.

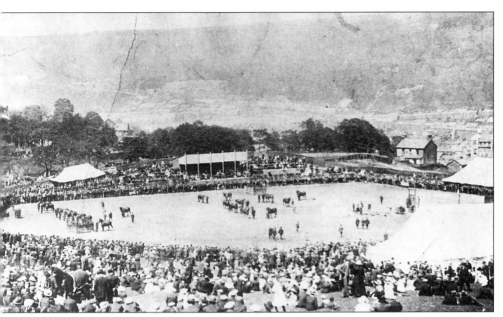

Annual horse show at Darran Park, Ferndale, *c.* 1900.

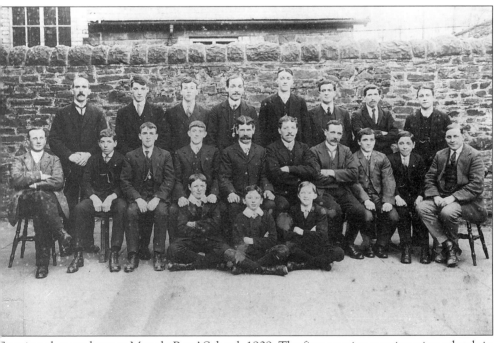

Evening class students at Maerdy Boys' School, 1909. The first evening continuation schools in the two Rhondda valleys were held at Ferndale on 19 May 1893 and at Pentre on 10 January 1894. The Rhondda Council Education Authority, which replaced the School Board following the Education Act of 1902, roundly embraced the notion of facilitating the self-improvement of the working man and was an enthusiastic promoter of evening classes. Many men were able to use this further education to become, for example, officials in local collieries.

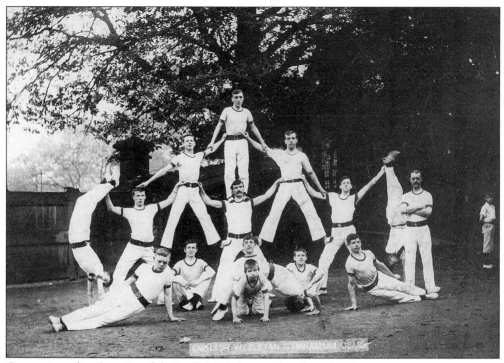

Gymnasium class from Ferndale English Wesleyan Church, *c.* 1910.

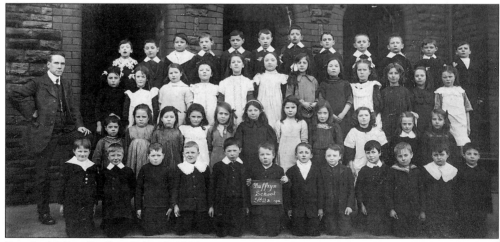

Standard 2 B at Duffryn School, 1914.

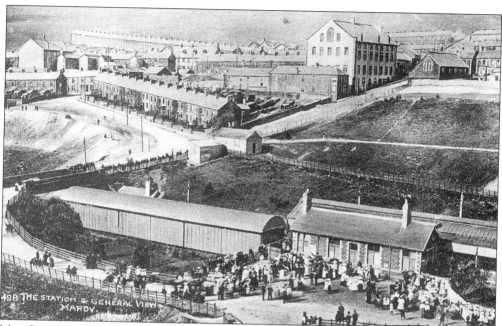

Maerdy railway station, possibly seen here on 18 June 1889 when it was opened to passenger traffic.

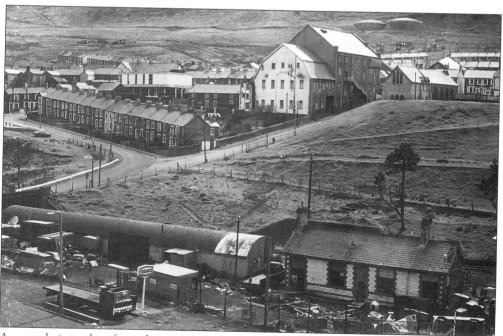

A second view taken from almost exactly the same position several decades later in the 1960s.

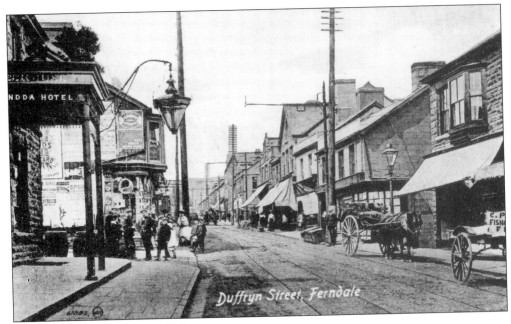

Duffryn Street, Ferndale, *c.* 1914.

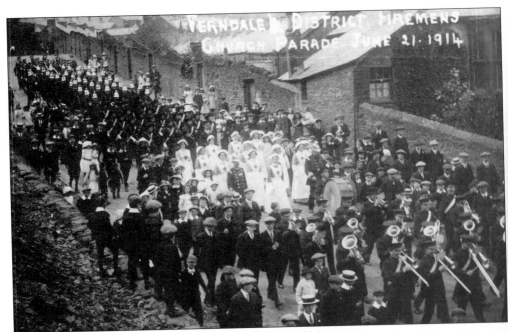

Ferndale & District Firemen's church parade, 21 June 1914.

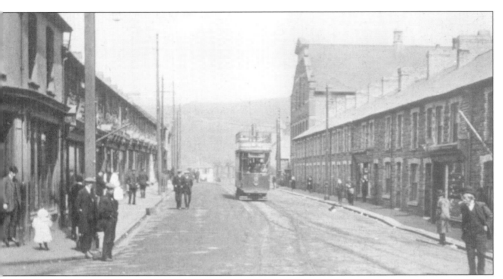

Ceridwen Street, Maerdy, *c*. 1920.

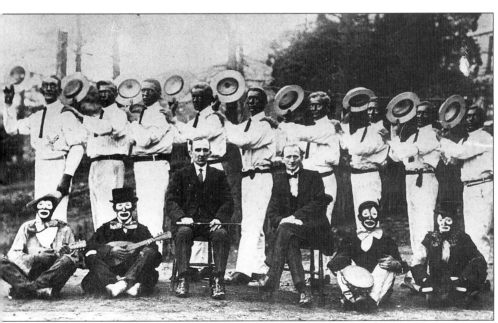

Members of the Nazareth Welsh Baptist Chapel, Blaenllechau in their costumes for a performance of *Holiday on the Sands*, 1919.

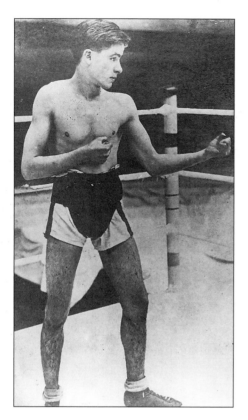

Harold Jones, professional bantamweight boxer from Ferndale who challenged unsuccessfully for the British title in 1919, losing to Scotsman, Jim Higgins in the thirteenth round when the referee controversially stopped the contest.

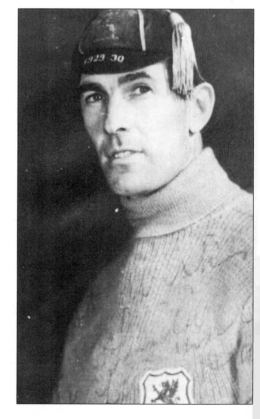

Dan Lewis, footballer, born in Maerdy in 1902. He moved to London in 1924 and until 1931 played as goalkeeper for Arsenal making 141 league appearances. He earned three caps for Wales appearing twice against England in 1927 and 1930 and once against Northern Ireland in 1930. Lewis' name has forever been associated with the 1927 F.A. Cup final during which he allowed a straightforward strike from Hughie Ferguson of Cardiff to slip under his body and into the net. It was the only goal of the game and Cardiff thereby took the F.A. Cup out of England for the first and only time in the competition's history. Although some have hinted at a sinister Taff conspiracy, the Arsenal camp at the time tended to place more blame on Lewis' shiny new goalkeeper's jersey.

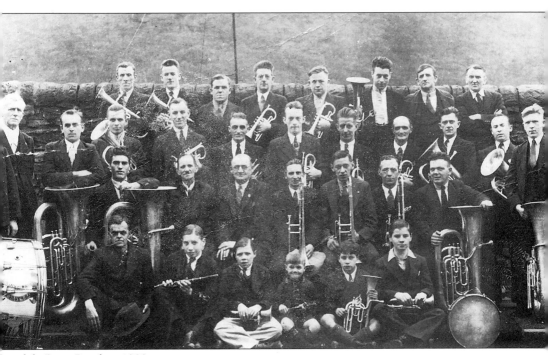

Ferndale Brass Band, *c.* 1930.

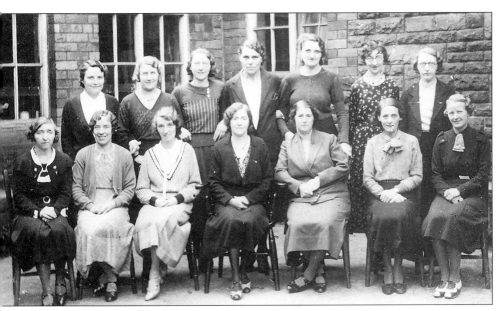

Ferndale Junior School staff, *c.* 1930.

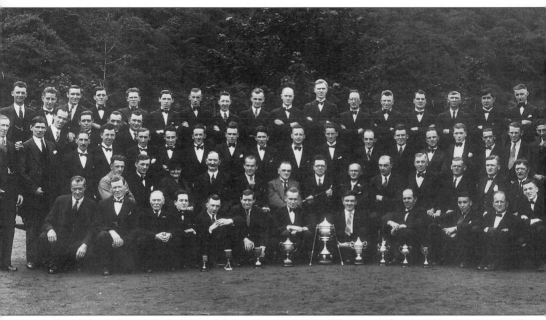

Ferndale Labour Club Male Voice Party, 1933. Their conductor, Mr Brinley William A.V.C.M. is holding the baton in the centre of the second row.

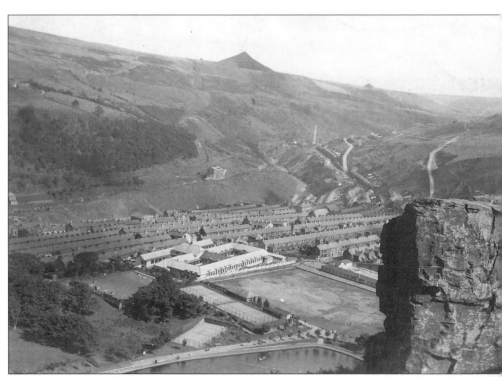

View of Ferndale, *c.* 1938, showing Llyn y Forwyn and Darran Park in the foreground.

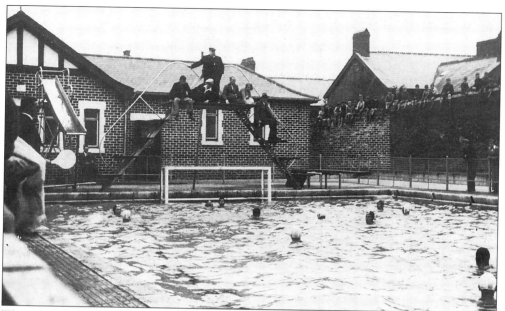

Water polo competition at Ferndale swimming baths, 1950.

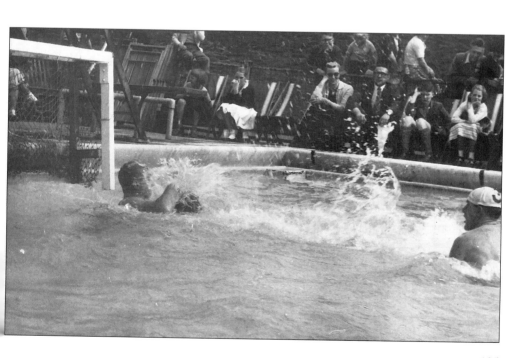

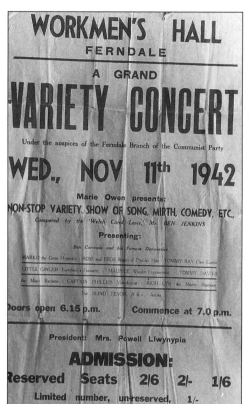

Poster advertising a wartime variety concert organised by the local branch of the Communist Party at Ferndale Workmen's Hall, 1942. The upper reaches of the Rhondda Fach were a particular hotbed of Communism and not for nothing did Maerdy earn the well-used nickname of 'Little Moscow'. In the 1929 General Election Arthur Horner the C.P. candidate took six thousand votes (15 per cent) in the Rhondda East constituency. By 1935 the Communist share of the vote had increased to 40 per cent and in the 1945 General Election, which swept Labour to power nationally, W.H. Mainwaring, the valley's Socialist M.P., came within a whisker of defeat when his Communist challenger Harry Pollitt polled 46 per cent of the vote. The shuddering political breakthrough, which the capture of a Labour heartland seat would have represented, was never to be achieved, however, and 1945 remains the zenith of Rhondda communism electorally.

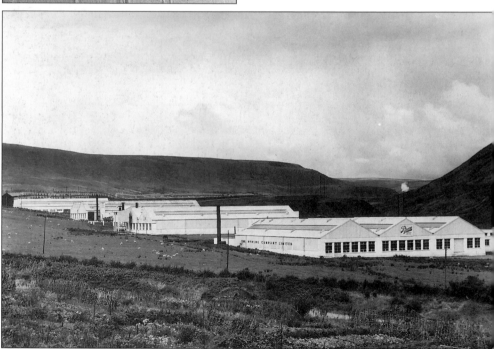

Pyrene Co. Ltd on the Ferndale Industrial Estate, c. 1955. The factory was used to make fire fighting appliances. The terraces of Maerdy can be seen in the background.

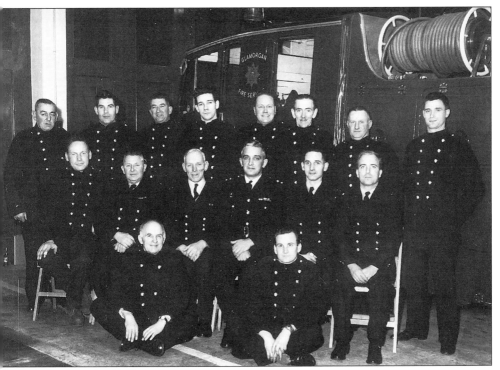

Ferndale fire brigade, 1965.

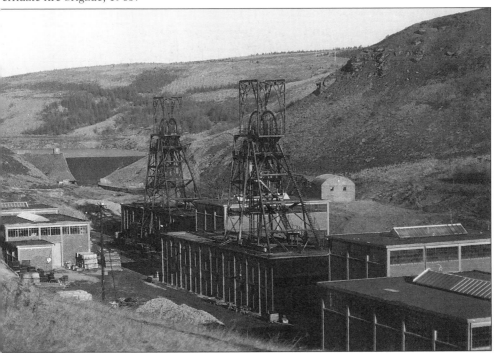

View of Mardy Colliery on 22 December 1990 - the last working day. In its last years Mardy was worked as one unit with Tower Colliery, Hirwaun; 30 June 1986 was the final day on which coal was actually raised in the Rhondda valleys.

Acknowledgements

The authors wish to thank the following individuals and organisations for their considerabl
help in the compilation of this our second selection of images from Rhondda's past.

We are particularly indebted to Margaret and Stan Wiltshire; Mr Aldo Bacchetta of Port
and Edna Evans of Ferndale who have willingly opened up their excellent photographi
collections, thus allowing us to improve considerably our intended publication.

We must extend our warm thanks to Susan Scott, Kay Warren-Morgan and Stephani
Thomas at Treorchy Central Library, and to Rhondda Borough Council, for grantin
permission to reproduce material from the photographic collection. Any queries we had wer
always rapidly and knowledgably dealt with and it is clear that local studies in the Rhondda
in very capable hands. May we also take this opportunity to once again invite the people c
Rhondda to ensure that, whenever possible, their photographs, postcards and general ephemer
are shared with, or left in the keeping of our splendid library service.

Glyn Davies; Barbara and Cliff Doughty; Lynne Evans; Roy Green; Mr & Mrs Hame
(Trehafod); Dave Hawkins; Mr & Mrs Harris (Trehafod); Jack Hart; John Hodder; Viv Jame.
Doreen Jenkins (for her patience and understanding); Cllr. Mrs Iris Jenkins; J. Jones; Mrs L
Jones and Mrs Kite (Gelli); Alf Laws; Cyril Lewis; Jeannie Lewis; Revd Jeffrey Long; Gordo
Miles; Roy Paul; Mrs Phillips (Ystrad); Alan Pickens; Irene Pickens; Gladys Rowsell; Gordo
Scott; Mrs D. Stark; Margaret Trudgeon; Will Williams.

A final thankyou goes to Mr Dewi Griffiths for his excellent introduction.

The late Arthur Hazzard to whom all students of local history in the Rhondda owe
considerable debt for his work over many years.

Stock List

(Titles are listed according to the pre-1974 county boundaries)

BERKSHIRE

Wantage
Irene Hancock
ISBN 0-7524-0146 7

CARDIGANSHIRE

Aberaeron and Mid Ceredigion
William Howells
ISBN 0-7524-0106-8

CHESHIRE

Ashton-under-Lyne and Mossley
Alice Lock
ISBN 0-7524-0164-5

Around Bebington
Pat O'Brien
ISBN 0-7524-0121-1

Crewe
Brian Edge
ISBN 0-7524-0052-5

Frodsham and Helsby
Frodsham and District Local History Group
ISBN 0-7524-0161-0

Macclesfield Silk
Moira Stevenson and Louanne Collins
ISBN 0-7524-0315 X

Marple
Steve Cliffe
ISBN 0-7524-0316-8

Runcorn
Bert Starkey
ISBN 0-7524-0025-8

Warrington
Janice Hayes
ISBN 0-7524-0040-1

West Kirby to Hoylake
Jim O'Neil
ISBN 0-7524-0024-X

Widnes
Anne Hall and the Widnes Historical Society
ISBN 0-7524-0117-3

CORNWALL

Padstow
Malcolm McCarthy
ISBN 0-7524-0033-9

St Ives Bay
Jonathan Holmes
ISBN 0-7524-0186-6

COUNTY DURHAM

Bishop Auckland
John Land
ISBN 0-7524-0312-5

Around Shildon
Vera Chapman
ISBN 0-7524-0115-7

CUMBERLAND

Carlisle
Dennis Perriam
ISBN 0-7524-0166-1

DERBYSHIRE

Around Alfreton
Alfreton and District Heritage Trust
ISBN 0-7524-0041-X

Barlborough, Clowne, Creswell and Whitwell
Les Yaw
ISBN 0-7524-0031-2

Around Bolsover
Bernard Haigh
ISBN 0-7524-0021-5

Around Derby
Alan Champion and Mark Edworthy
ISBN 0-7524-0020-7

Long Eaton
John Barker
ISBN 0-7524-0110-6

Ripley and Codnor
David Buxton
ISBN 0-7524-0042-8

Shirebrook
Geoff Sadler
ISBN 0-7524-0028-2

Shirebrook: A Second Selection
Geoff Sadler
ISBN 0-7524-0317-6

DEVON

Brixham
Ted Gosling and Lyn Marshall
ISBN 0-7524-0037-1

Around Honiton
Les Berry and Gerald Gosling
ISBN 0-7524-0175-0

Around Newton Abbot
Les Berry and Gerald Gosling
ISBN 0-7524-0027-4

Around Ottery St Mary
Gerald Gosling and Peter Harris
ISBN 0-7524-0030-4

Around Sidmouth
Les Berry and Gerald Gosling
ISBN 0-7524-0137-8

DORSET

Around Uplyme and Lyme Regis
Les Berry and Gerald Gosling
ISBN 0-7524-0044-4

ESSEX

Braintree and Bocking
John and Sandra Adlam and Mark Charlton
ISBN 0-7524-0129-7

Ilford
Ian Dowling and Nick Harris
ISBN 0-7524-0050-9

Ilford: A Second Selection
Ian Dowling and Nick Harris
ISBN 0-7524-0320-6

Saffron Walden
Jean Gumbrell
ISBN 0-7524-0176-9

GLAMORGAN

Around Bridgend
Simon Eckley
ISBN 0-7524-0189-0

Caerphilly
Simon Eckley
ISBN 0-7524-0194-7

Around Kenfig Hill and Pyle
Keith Morgan
ISBN 0-7524-0314-1

The County Borough of Merthyr Tydfil
Carolyn Jacob, Stephen Done and Simon Eckley
ISBN 0-7524-0012-6

Mountain Ash, Penrhiwceiber and Abercynon
Bernard Baldwin and Harry Rogers
ISBN 0-7524-0114-9

Pontypridd
Simon Eckley
ISBN 0-7524-0017-7

Rhondda
Simon Eckley and Emrys Jenkins
ISBN 0-7524-0028-2

Rhondda: A Second Selection
Simon Eckley and Emrys Jenkins
ISBN 0-7524-0308-7

Roath, Splott, and Adamsdown
Roath Local History Society
ISBN 0-7524-0199-8

GLOUCESTERSHIRE

Barnwood, Hucclecote and Brockworth
Alan Sutton
ISBN 0-7524-0000-2

Forest to Severn
Humphrey Phelps
ISBN 0-7524-0008-8

Filton and the Flying Machine
Malcolm Hall
ISBN 0-7524-0171-8

Gloster Aircraft Company
Derek James
ISBN 0-7524-0038-X

The City of Gloucester
Jill Voyce
ISBN 0-7524-0306-0

Around Nailsworth and Minchinhampton from the Conway Collection
Howard Beard
ISBN 0-7524-0048-7

Around Newent
Tim Ward
ISBN 0-7524-0003-7

Stroud: Five Stroud Photographers
Howard Beard, Peter Harris and Wilf Merrett
ISBN 0-7524-0305-2

HAMPSHIRE

Gosport
Ian Edelman
ISBN 0-7524-0300-1

Winchester from the Sollars Collection
John Brimfield
ISBN 0-7524-0173-4

HEREFORDSHIRE

Ross-on-Wye
Tom Rigby and Alan Sutton
ISBN 0-7524-0002-9

HERTFORDSHIRE

Buntingford
Philip Plumb
ISBN 0-7524-0170-X

Hampstead Garden Suburb
Mervyn Miller
ISBN 0-7524-0319-2

Hemel Hempstead
Eve Davis
ISBN 0-7524-0167-X

Letchworth
Mervyn Miller
ISBN 0-7524-0318-4

Welwyn Garden City
Angela Eserin
ISBN 0-7524-0133-5

KENT

Hythe
Joy Melville and Angela Lewis-Johnson
ISBN 0-7524-0169-6

North Thanet Coast
Alan Kay
ISBN 0-7524-0112-2

Shorts Aircraft
Mike Hooks
ISBN 0-7524-0193-9

LANCASHIRE

Lancaster and the Lune Valley
Robert Alston
ISBN 0-7524-0015-0

Morecambe Bay
Robert Alston
ISBN 0-7524-0163-7

Manchester
Peter Stewart
ISBN 0-7524-0103-3

LINCOLNSHIRE

Louth
David Cuppleditch
ISBN 0-7524-0172-6

Stamford
David Gerard
ISBN 0-7524-0309-5

LONDON
(Greater London and Middlesex)

Battersea and Clapham
Patrick Loobey
ISBN 0-7524-0010-X

Canning Town
Howard Bloch and Nick Harris
ISBN 0-7524-0057-6

Chiswick
Carolyn and Peter Hammond
ISBN 0-7524-0001-0

Forest Gate
Nick Harris and Dorcas Sanders
ISBN 0-7524-0049-5

Greenwich
Barbara Ludlow
ISBN 0-7524-0045-2

Highgate and Muswell Hill
Joan Schwitzer and Ken Gay
ISBN 0-7524-0119-X

Islington
Gavin Smith
ISBN 0-7524-0140-8

Lewisham
John Coulter and Barry Olley
ISBN 0-7524-0059-2

Leyton and Leytonstone
Keith Romig and Peter Lawrence
ISBN 0-7524-0158-0

Newham Dockland
Howard Bloch
ISBN 0-7524-0107-6

Norwood
Nicholas Reed
ISBN 0-7524-0147-5

Peckham and Nunhead
John D. Beasley
ISBN 0-7524-0122-X

Piccadilly Circus
David Oxford
ISBN 0-7524-0196-3

Stoke Newington
Gavin Smith
ISBN 0-7524-0159-9

Sydenham and Forest Hill
John Coulter and John Seaman
ISBN 0-7524-0036-3

Wandsworth
Patrick Loobey
ISBN 0-7524-0026-6

Wanstead and Woodford
Ian Dowling and Nick Harris
ISBN 0-7524-0113-0

MONMOUTHSHIRE

Vanished Abergavenny
Frank Olding
ISBN 0-7524-0034-7

Abertillery, Aberbeeg and Llanhilleth
Abertillery and District Museum Society and Simon Eckley
ISBN 0-7524-0134-3

Blaina, Nantyglo and Brynmawr
Trevor Rowson
ISBN 0-7524-0136-X

NORFOLK

North Norfolk
Cliff Richard Temple
ISBN 0-7524-0149-1

NOTTINGHAMSHIRE

Nottingham 1897–1947
Douglas Whitworth
ISBN 0-7524-0157-2

OXFORDSHIRE

Banbury
Tom Rigby
ISBN 0-7524-0013-4

PEMBROKESHIRE

Saundersfoot and Tenby
Ken Daniels
ISBN 0-7524-0192-0

RADNORSHIRE

Llandrindod Wells
Chris Wilson
ISBN 0-7524-0191-2

SHROPSHIRE

Leominster
Eric Turton
ISBN 0-7524-0307-9

Ludlow
David Lloyd
ISBN 0-7524-0155-6

Oswestry
Bernard Mitchell
ISBN 0-7524-0032-0

North Telford: Wellington, Oakengates, and Surrounding Areas
John Powell and Michael A. Vanns
ISBN 0-7524-0124-6

South Telford: Ironbridge Gorge, Madeley, and Dawley
John Powell and Michael A. Vanns
ISBN 0-7524-0125-4

SOMERSET

Bath
Paul De'Ath
ISBN 0-7524-0127-0

Around Yeovil
Robin Ansell and Marion Barnes
ISBN 0-7524-0178-5

STAFFORDSHIRE

Cannock Chase
Sherry Belcher and Mary Mills
ISBN 0-7524-0051-7

Around Cheadle
George Short
ISBN 0-7524-0022-3

The Potteries
Ian Lawley
ISBN 0-7524-0046-0

East Staffordshire
Geoffrey Sowerby and Richard Farman
ISBN 0-7524-0197-1

SUFFOLK

Lowestoft to Southwold
Humphrey Phelps
ISBN 0-7524-0108-4

Walberswick to Felixstowe
Humphrey Phelps
ISBN 0-7524-0109-2

SURREY

Around Camberley
Ken Clarke
ISBN 0-7524-0148-3

Around Cranleigh
Michael Miller
ISBN 0-7524-0143-2

Epsom and Ewell
Richard Essen
ISBN 0-7524-0111-4

Farnham by the Wey
Jean Parratt
ISBN 0-7524-0185-8

Industrious Surrey: Historic Images of the County at Work
Chris Shepheard
ISBN 0-7524-0009-6

Reigate and Redhill
Mary G. Goss
ISBN 0-7524-0179-3

Richmond and Kew
Richard Essen
ISBN 0-7524-0145-9

SUSSEX

Billingshurst
Wendy Lines
ISBN 0-7524-0301-X

WARWICKSHIRE

Central Birmingham 1870–1920
Keith Turner
ISBN 0-7524-0053-3

Old Harborne
Roy Clarke
ISBN 0-7524-0054-1

WILTSHIRE

Malmesbury
Dorothy Barnes
ISBN 0-7524-0177-7

Great Western Swindon
Tim Bryan
ISBN 0-7524-0153-X

Midland and South Western Junction Railway
Mike Barnsley and Brian Bridgeman
ISBN 0-7524-0016-9

WORCESTERSHIRE

Around Malvern
Keith Smith
ISBN 0-7524-0029-0

YORKSHIRE
(EAST RIDING)

Hornsea
G.L. Southwell
ISBN 0-7524-0120-3

YORKSHIRE
(NORTH RIDING)

Northallerton
Vera Chapman
ISBN 0-7524-055-X

Scarborough in the 1970s and 1980s
Richard Percy
ISBN 0-7524-0325-7

YORKSHIRE
(WEST RIDING)

Barnsley
Barnsley Archive Service
ISBN 0-7524-0188-2

Bingley
Bingley and District Local History Society
ISBN 0-7524-0311-7

Bradford
Gary Firth
ISBN 0-7524-0313-3

Castleford
Wakefield Metropolitan District Council
ISBN 0-7524-0047-9

Doncaster
Peter Tuffrey
ISBN 0-7524-0162-9

Harrogate
Malcolm Neesam
ISBN 0-7524-0154-8

Holme Valley
Peter and Iris Bullock
ISBN 0-7524-0139-4

Horsforth
Alan Cockroft and Matthew Young
ISBN 0-7524-0130-0

Knaresborough
Arnold Kellett
ISBN 0-7524-0131-9

Around Leeds
Matthew Young and Dorothy Payne
ISBN 0-7524-0168-8

Penistone
Matthew Young and David Hambleton
ISBN 0-7524-0138-6

Selby from the William Rawling Collection
Matthew Young
ISBN 0-7524-0198-X

Central Sheffield
Martin Olive
ISBN 0-7524-0011-8

Around Stocksbridge
Stocksbridge and District History Society
ISBN 0-7524-0165-3

TRANSPORT

Filton and the Flying Machine
Malcolm Hall
ISBN 0-7524-0171-8

Gloster Aircraft Company
Derek James
ISBN 0-7524-0038-X

Great Western Swindon
Tim Bryan
ISBN 0-7524-0153-X

Midland and South Western Junction Railway
Mike Barnsley and Brian Bridgeman
ISBN 0-7524-0016-9

Shorts Aircraft
Mike Hooks
ISBN 0-7524-0193-9

This stock list shows all titles available in the United Kingdom as at 30 September 1995.

ORDER FORM

The books in this stock list are available from your local bookshop. Alternatively they are available by mail order at a totally inclusive price of £10.00 per copy.

For overseas orders please add the following postage supplement for each copy ordered:
 European Union £0.36 (this includes the Republic of Ireland)
 Royal Mail Zone 1 (for example, U.S.A. and Canada) £1.96
 Royal Mail Zone 2 (for example, Australia and New Zealand) £2.47

Please note that all of these supplements are actual Royal Mail charges with no profit element to the Chalford Publishing Company. Furthermore, as the Air Mail Printed Papers rate applies, we are restricted from enclosing any personal correspondence other than to indicate the senders name.

Payment can be made by cheque, Visa or Mastercard. Please indicate your method of payment on this order form.

If you are not entirely happy with your purchase you may return it within 30 days of receipt for a full refund.

Please send your order to:

 The Chalford Publishing Company,
 St Mary's Mill,
 Chalford,
 Stroud,
 Gloucestershire
 GL6 8NX

This order form should perforate away from the book. However, if you are reluctant to damage the book in any way we are quite happy to accept a photocopy order form or a letter containing the necessary information.

PLEASE WRITE CLEARLY USING BLOCK CAPITALS

Name and address of the person ordering the books listed below:

_____ Post code _____

Please also supply your telephone number in case we have difficulty fully understanding your requirements. Tel.: _____ - _____

Name and address of where the books are to be despatched to (if different from above):

_____ Post code _____

Please indicate here if you would like to receive future information on books published by the Chalford Publishing Company.

____ Yes, please put me on your mailing list ____ No, please just send the books ordered below

Title	ISBN	Quantity
...	0-7524-_____-___	_____
...	0-7524-_____-___	_____
...	0-7524-_____-___	_____
...	0-7524-_____-___	_____
...	0-7524-_____-___	_____
	Total number of books	_____

Cost of books delivered in UK = Number of books ordered @ £10 each	=£	_____
Overseas postage supplement (if relevant)	=£	_____
TOTAL PAYMENT	=£	_____

Method of Payment ❑ Cheque ❑ Visa ❑ Mastercard

Please make cheques payable to *The Chalford Publishing Company*

Name of Card Holder _____

Card Number ❑❑❑❑❑❑❑❑❑❑❑❑❑❑❑❑❑❑❑❑

Expiry date ❑❑ / ❑❑

I authorise payment of £_____ from the above card

Signed _____